ISBN 1-85444-182-5

9 781854 441829

ASHMOLEAN MUSEUM · OXFORD · CHRIS BEETLES LIMITED

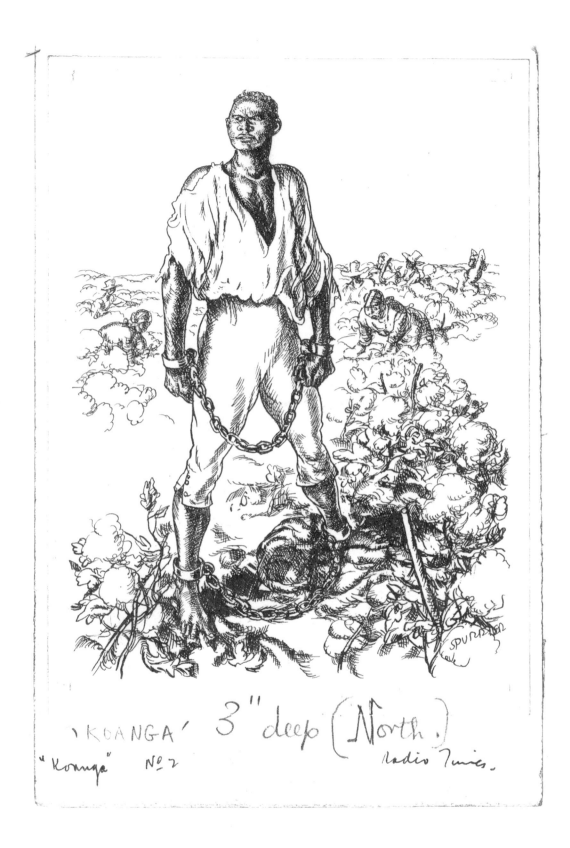

'KOANGA' 3" deep (North.)

"Koanga" Nº 2

Radio Times.

Stephen Spurrier,
'Koanga',
Radio Times,
1950s

Acknowledgements

MY GRATEFUL THANKS to all the illustrators and their families who are represented by this exhibition and history, for their generosity in supplying original work, for volunteering information and for their kindness and continuous encouragement throughout its difficult gestation; to the Ashmolean Museum and DR. JON WHITELEY for making it possible, and GERALDINE GLYNN for her patient administration; ALBERT CANE for transpotation, and JULIA ROWE for additional art historical research and support throughout.

In gratitude to HAROLD COHEN for his inspiring tuition at Brighton College of Art; and GABRIELLE STODDART for encouraging me to illustrate, her confidence in supporting me while I learned and, in 1974, unselfishly taking my inadequate portfolio of illustrations to *Radio Times*.

To EDWARD BOOTH-CLIBBORN for permission to use David Driver's *The Art of Radio Times*, for primary research; TONY CURRY for permission to extract historical details from *The Radio Times Story*; likewise to ALAN HORNE for selected biographical information from *The Dictionary of 20th Century Book Illustrators*; and DAVID WOOTTON at Chris Beetles Limited for *The ILLUSTRATORS The British Art of Illustration, 1800-1997*; SIMON BRETT for information about Derrick Harris; MARGARET LEVETUS and JUSTINE HOPKINS for information about Michæl Ayrton; SIMON ALBERT, IAN MACKENZIE-KERR and MIM STRIBLEY for information about Gaynor Chapman; NAOMI PRITCHARD and Thames and Hudson for their kindness and help with loan of work by this artist; MARY and GEOFFREY FRASER for information about and loan of works by Eric Fraser, and BRIAN SIBLEY, adaptor of Tolkien's *The Lord of the Rings* for the loan of Eric Fraser's cover for this BBC *Radio 4* production; LUKE GERTLER for his kindness, generosity and loan of significant works; ANNE VALERY for information about Robin Jacques; JÜRGEN SCHADEBURG for his kind permission to reproduce his photograph of Robin; DOUGLAS MARTIN for information about Faith Jaques; CHRISTOPHER WINTLE, Senior Lecturer in Music, King's College, London, for his hospitality and information about Milein Cosman and Hans Keller;

BERNARD CROSSLEY for loan of material; BRIAN WEBB for loan of work by Edward Ardizzone; and WALLACE GREVATT, historian and archivist of the BBC and *Radio Times,* for his authoritative correction of historical details in the manuscript.

JACQUIE KAVANAGH, CAROLE BURCHETT, MARION FALLON and NEIL SOMERVILLE at the BBC Written Archive Centre, for their courtesy, coffee and enthusiasm; RICHARD KNIGHT at Mission 21; MARY PORTALSKA of the BBC Photo Library; SIMON CLARKSON and RUTH SANDERS of BBC Worldwide Marketing; NATALIE FORKIN, Brand Manager, *Radio Times*; ROBIN REYNOLDS, Head of Archive at the BBC; SUE ALDWORTH, JENNY FLEET, VERONICA HITCHCOCK, NIGEL HORNE, ROGER HUGHES, ROBERT PRIEST, PAUL SMITH, BRIAN THOMAS and DEREK UNGLESS, past and present members of *Radio Times* Editorial Department.

Additional thanks to DAVID DRIVER, Head of Design and Assistant Editor *The Times* for his enthusiasm, support and substantial advice; MISS BARBARA THOMPSON of the *Saxon Artist Agency* for her help and loan of work by Terence Greer; GEOFFREY BEARE of *The Imaginative Book Illustration Society*; KATHY JENKINS of the *European Illustration Collection*, Hull; MARTIN COLYER at *Reader's Digest*; JOHN HUDDY of *The Illustration Cupboard*; THE ASSOCIATION OF ILLUSTRATORS; VICTORIA WILLIAMS of the Hastings Museum and Art Gallery; PROFESSOR JOHN LORD and LEONARD ROSOMAN for their continual support; and FRITZ WEGNER for his kindness and wisdom.

Especial gratitude to MR AND MRS HAROLD COHEN; MR AND MRS ANDREW DEACON; MRS ANN GILBERT; JOHN FRANCIS GUILFOYLE and MR AND MRS CRISPIN HODGES for their hospitality; and to ARI LAAKKONEN, CIARA MAGEE and JAMES TINWORTH of Linklaters & Alliance and also UMESH MISTRI of DACS, for their collective support and great altruism.

In loving memory of MRS PEGGY WILSON, 1915-1981; and ASSIA WEVILL, 1927-1969 and her daughter, SHURA. *martinbaker2002@hotmail.com.*

Notes

1. James Hyman, *The Battle for Realism: Figurative Art in Britain during the Cold War (1945/60)*, Yale University Press, 2001.

2. Asa Briggs, quoted in David Driver, *The Art of Radio Times*, European Illustration/BBC Publications, 1981.

3. Maurice Gorham, *Sound and Fury, Twenty One Years in the BBC*, Percival Marshall, 1948.

4. *ibid.*

5. *ibid.*

6. Tony Currie, *The Radio Times Story*, Kelly Publications, 2001.

7. *ibid.*

8. *ibid.*

9. Maurice Gorham, *Sound and Fury, Twenty One Years in the BBC*, Percival Marshall, 1948.

10. Hodges to author, 2000.

11. Joanna Carey, *The Guardian,* 4 January, 2000.

12. A white gesso board, traditionally coated in black, where a stylus is used to scrape away the surface pigment to emulate wood cut, engraving, and on occasions, photographic half-tone; also available with a white surface, and also with grained textures where the artist makes an initial drawing in black ink from which detail is recovered with incisions.

13. Maurice Gorham, *Sound and Fury, Twenty One Years in the BBC*, Percival Marshall, 1948.

14. Levetus to author, 2001.

15. Hitchcock to author, 2001.

16. Cohen to author, 2001.

17. Once ascribed to Pergolesi, the original concerti are now thought to have been written by van Wassenær.

18. Coupland to author, 2002

19. The first issue published from 35a Marylebone High Street was dated 16-22 March 1950.

20. Simon Brett, *Mr Derek Harris*, The Fleece Press, 1999.

21. Ralph Usherwood, *Drawing for Radio Times*, The Bodley Head, 1961.

22. Simon Brett, *Mr Derek Harris*, The Fleece Press, 1999.

23. Cohen to author 2001.

24. Micklewright to author, 2001.

25. Ralph Usherwood, *Drawing for Radio Times*, The Bodley Head, 1961.

26. Dodds to author, 2001.

27. *ibid.*

28. *ibid.*

29. Ralph Usherwood, *Drawing for Radio Times*, The Bodley Head, 1961.

30. Tony Currie, *The Radio Times Story*, Kelly Publications, 2001.

31. Driver to author, 2001.

32. *ibid.*

33. Lord to author, 2001.

34. Gray to author, 2001.

35. *ibid.*

36. Firmin to author, 2000.

37. Sanderson to author, 2000.

38. Ellison to author, 2000.

39. *ibid.*

40. Knock to author, 2001.

41. McSweeney to author, 2001.

42. Robert Mason, *A Digital Dolly?, a subjective survey of British Illustration in the 1990s*, Norwich School of Art and Design, 2000.

43. Mason to author, 2001.

44. Priest to author, 2000.

45. Ungless to author, 2001.

46. Hughes to author, 2001.

Val Biro, 'The Seasons', Radio Times, 1960s

WILKINSON, Barry (1923-) Born at Dewsbury, Yorkshire. Initially studied at Dewsbury School of Art then, after service in the RAF during WWII, went to the RCA. Worked in a stained glass studio; taught at Wimbledon School of Art; created animation designs for a film studio. In 1961 became a free-lance illustrator demonstrating an oustanding sense of design, draughtsmanship and use of mediums.

WOOD, Owen (1929-) Born at Whetstone, London; studied art at Camberwell School of Arts and Crafts, (1945-47); worked as a free-lance painter and illustrator with exceptional command of technique; taught at Cambridge College of Art, (1960-1964); then at Ipswich, Norwich and Reigate Schools of Art; designed banknotes for the Clydesdale Bank of Scotland; created a series of 12 large murals which are suspended from the ceiling of the London Stock Exchange's public gallery; illustrated *Radio Times* covers, 1974, 1975.

WOOLLEY, Janet (1952-) Studied at Brighton College of Art until 1973; went to RCA to study illustration (1973-76) under Dan Fern and Quentin Blake. Contributed to *The Times*, *Radio Times*, *The Sunday Times*, *TES* while still a student and, on leaving the RCA, continued to work for these magazines. Began working for clients in the USA in 1981, including *Esquire* magazine and *Rolling Stone*, to which she still contributes. Tutor B. A. illustration and postgraduate and M. A. illustration courses at Central St. Martin's School of Art (1985-). Winner of Society of Illustrators' (USA) *Gold Medal* (1989); D&AD *Silver Award* for illustration in advertising (1994). Visiting Professor to the London Institute since 1996.

Barry Wilkinson, 'The House with Green Shutters', Radio Times, 20th March 1969

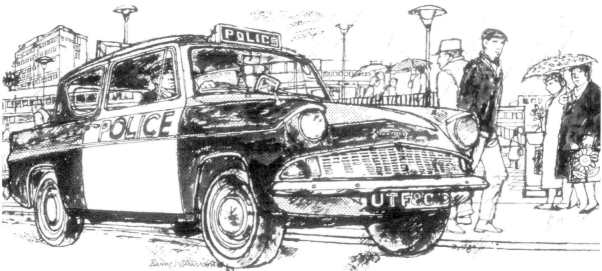

Barry Wilkinson, 'Z Cars', Radio Times, 22nd August 1968

WATTS, Arthur (1883-1935) Educated at Dulwich, studied art in Paris, Antwerp and in London at The Slade. Cartoons contributed to *Radio Times* from 1928 until his death in an aircrash on his way home from Italy.

WEGNER, Fritz (1924-) Born in Vienna. Came to England as refugee in 1938. Throughout WWII he was forced to work on the land as he was classified as an 'enemy alien'. Won scholarship to St. Martin's School of Art, where he subsequently taught graphic design. After the war he became a free-lance illustrator, designing book jackets, contributing to magazines and also designing postage stamps. His recent work includes children's books, in collaboration with Allan Ahlberg and Michæl Rosen.

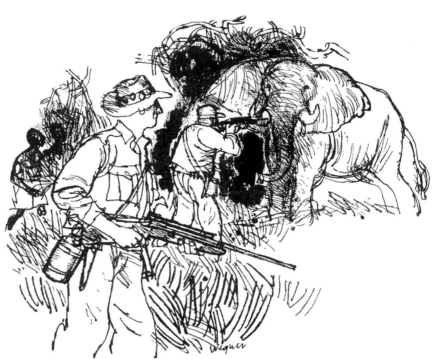

Fritz Wegner, 'Elephant Hunters', Radio Times, 19ᵗʰ May 1966

Fritz Wegner, 'Waters of the Moon', Radio Times, 27ᵗʰ May 1955

TUNNICLIFFE, Charles F. (1901-79)
Born at Langley, near Macclesfield,
Cheshire, educated at St James' School,
Sutton; scholarship to study art at
Macclesfield Art School (1915); Manchester
Art School (1915-21); RCA (1921-25); early
recognition for his prowess as an etcher
and wood engraver brought him
commissions to illustrate books, an early
success was his collaboration with Henry
Williamson for *Tarka the Otter* (1932) and
Salar the Salmon (1936). His wild-life
scraperboard drawings for *Radio Times* and
other publications are models of
observation and technical ability, these he
contributed from his home at Anglesea.
Elected ARE (1929); ARA (1944); RA
(1954); made Vice President of SWLA
(1968); O.B.E. (1978).

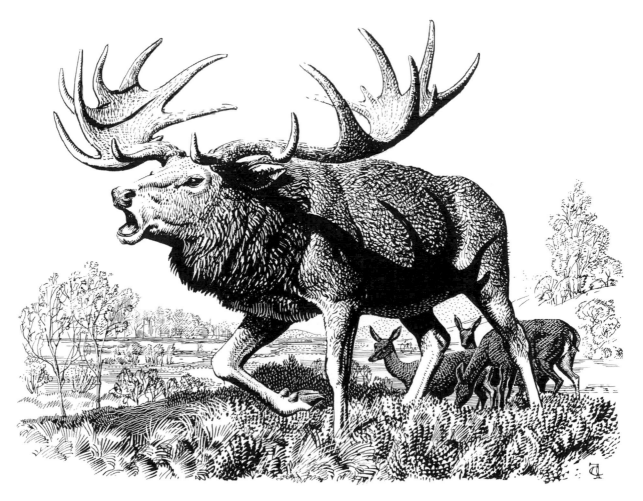

Charles Tunnicliffe, 'The Great Ancestral Deer', Radio Times, 18th August 1966

STODDART, Gabrielle (1943-) Studied illustration at Brighton College of Art (1960-63). Free-lanced on leaving college, specialising in children's and educational books. Illustrated *One Two Number Zoo*, a children's counting book, Hodder and Stoughton (1981). Illustrations for books commissioned by UK and European publishers. In recent years has become a distinguished fine artist, specialising in portrait, wildlife and landscape painting. Tutor at various colleges in East Anglia.

Gabrielle Stoddart, 'The Field', pencil, 1980s

John Storey, self-portrait, 2002

STOREY, John (1948-) Foundation course at South East Essex Technical College. Studied illustration at Bristol Polytechnic Faculty of Art and Design (1967-70). From 1970 has free-lanced as illustrator for most national newspapers and magazines. First worked for *Radio Times* in 1970.

THOMAS, Mark (1954-) Born in London. Studied art at St. Albans School of Art; Kingston upon Thames Polytechnic. From 1976 free-lance illustrator. First commissioned by *Radio Times* in 1976. Credit sequence for BBC TV's *The Singing Detective* won BAFTA award, 1987.

TILL, Peter (1945-) Born in Manchester; read English at Cambridge University (1964-67); started selling drawings to *OZ* magazine (1969); joined *Flies Revue* (1970); began to get illustration commissions from 1973; wrote and designed storyboard for short film *The Beard*, which was animated in 1978 by Ian Emes; contributed work to *The Times, The Sunday Times, New York magazine, New York Times*, also magazines in Australia, Germany and France. Became member of Graphique Alliance Internationale in 2000.

John Storey, 'Wogan's Panto Special', Radio Times, 1988

SLATER, Paul (1953) Born at Burnley and
studied art at Burnley Technical College;
Maidstone College of Art and
the RCA. As one of Britain's leading
free-lance painters and illustrators he has
worked continuously for newspapers,
magazines, and also in advertising,
television and cinema. His first *Radio
Times* illustration was for the cover
featuring the series, *Artists and Models*,
(1986).

SPURRIER, Steven (1878-1961) Born in
London; at 17, whilst working as an
apprenticed to a silversmith, he studied art
in the evenings at Heatherley's;
contributed work to several magazines:
Madam, Black and White and *Graphic*;
during the war served in the Port Police
and the RNVR; was demobbed and joined
the staff of the *Illustrated Evening News*;
His career as a landscape and figure
painter, exhibiting at the RA from 1913,
brought him renown; first drew for *Radio
Times* in 1928.

Stephen Spurrier,
'Buccaneer',
Radio Times,
1930s

Stephen Spurrier,
Radio Times,
1930s

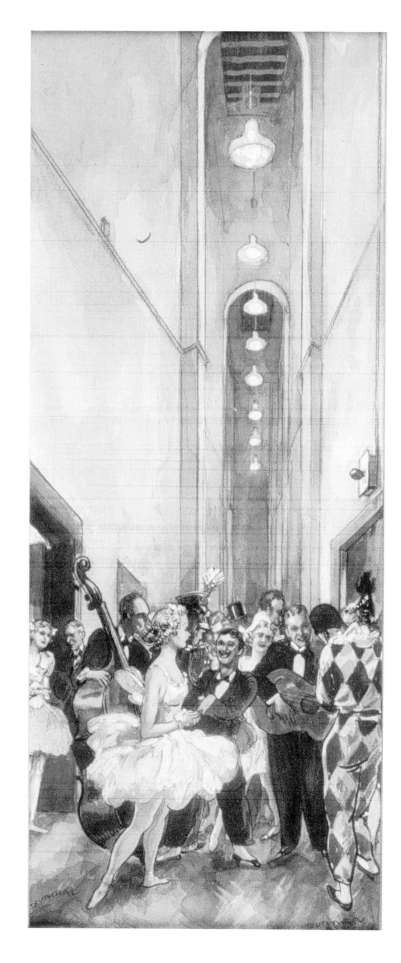

SCARFE, Laurence (1914-2000) Born at Bradford; studied mural painting at the RCA; taught at Bromley School of Art (1937-39); Central School of Art and Design (1945-70); Brighton College of Art (1961); worked in a free-lance capacity as illustrator and as an art editor and contributor to *The Saturday Book*. His journeys throughout Europe resulted in many books on travel and the Italian Baroque. He first drew for the *Radio Times* in 1947.

Laurence Scarfe,
'A Midsummer Night's Dream',
Radio Times, 10th June 1966

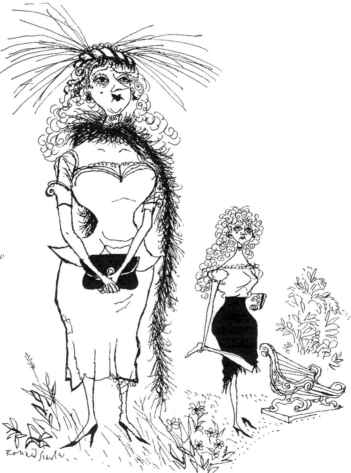

SEARLE, Ronald (1920-) Born at Cambridge; studied at Cambridge School of Art. His first cartoons were published in *Cambridge Daily News* and *Granta* (1935-39); served in the army during WWII; taken prisoner of war in 1942 and remained in Siam and Malaya until 1945; his *Forty Drawings* (1946) reproduce the record of imprisonment he made during incarceration by the Japanese; creator of the *Schoolgirls of St Trinian's;* cartoonist to *Tribune* (1949-51); *Sunday Express,* (1950-51); special features artist, *News Chronicle* (1951-53); weekly cartoonist, *News Chronicle* (1954); contributor to *New Yorker*. He has designed film animations including *Those Magnificent Men in their Flying Machines*, and produced many books.

Ronald Searle,
It is proposed to use this
donation for the purchase of
new wenches for our park as
the present old ones
are in a very dilapidated state.
Collection Luke Gertler.

RUSSELL, Jim (1933-) Born at Walsall, Staffordshire; educated at the Royal School, Wolverhampton; studied art at Birmingham College of Arts and Crafts (1951). After National Service in Singapore he returned to study for an Art Teacher's Diploma in Birmingham. Taught part-time at St Martin's School of Art in the 1960s. Joined Saxon Artists and began a free-lance career. His drawings for *Radio Times*, to which he contributed throughout the 1960s, utilise innovative technical skill and great artistry. RBA (1995). Elected ARWS (2001).

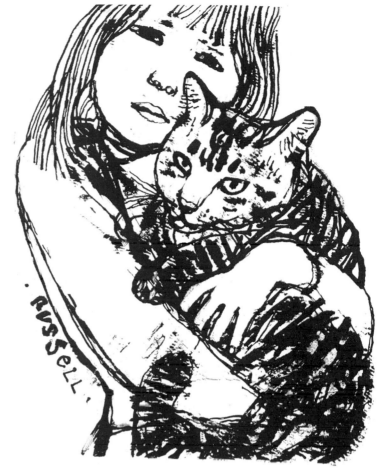

Jim Russell, Radio Times, 1960s

SANDERSON, Bill (1948-) Attended Bristol Polytechnic Faculty of Art. After teaching part-time, and on the advice of Charlie Riddell of *New Society*, he developed a scraperboard style based on the techniques of Victorian engravers. He first worked for *Radio Times* in 1974 and has subsequently free-lanced for publishers and advertising agencies.

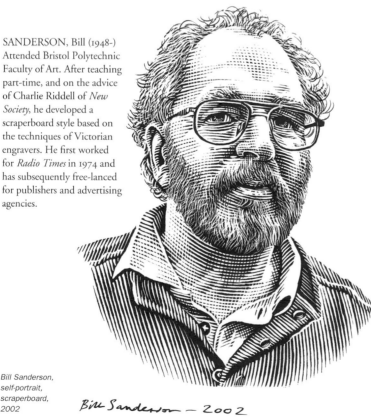

Bill Sanderson, self-portrait, scraperboard, 2002

ROSOMAN, Leonard (1913-) Born in Hampstead, London; educated at Deacons School, Peterborough; studied art at King Edward VII School of Art, Durham University (1930-34), the RA Schools (1935-36), Central School of Arts and Crafts (1938-39). Taught illustration at Camberwell School of Art (1946-48); Edinburgh College of Art (1948-56); Chelsea School of Art (1956-57); RCA (1957-58). Served in Auxiliary Fire Service at beginning of the war, then appointed official war artist to the Admiralty (1944), He first drew for *Radio Times* in 1951. One of Britain's most influential artists and an outstanding colourist. Elected ARA (1960), RA (1970), O.B.E. (1981).

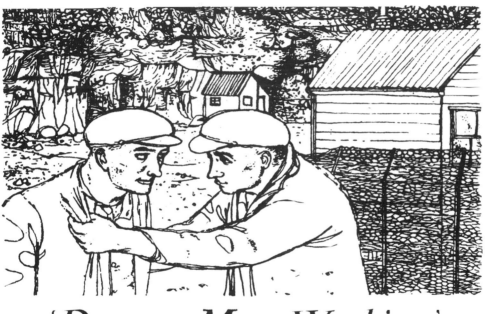

'Danger, Men Working'

Adapted for broadcasting by the author, J D STEWART

Mary Reilly, *a shorthand typist*.........................Patricia Stewart
Desmond Doherty. *general foreman*.....................Joseph Tomelty
Erskine Craig, *a civil engineer*.........................Allan McClelland
Paddy Hoy, *a disabled craftsman*............................J G Devlin
Gerry McMahon, *a navvy*................. Patrick McAlinney
Charlie Quinn, *a foreman*...John McBride
Sam Toler, *a ganger* Noel French
John Peoples, *a foreman*...Will Leighton
Fred Scanling, *a chief ganger*..Pat Magee
Major Trumbull, *Engineer in Charge*...................Michael Kelly

The play is set in Northern Ireland, on a site where a hospital is under construction, and it examines the impact of mass-production methods and mass-production mentality on a community of workmen accustomed to other, more personal methods

PRODUCED BY TYRONE GUTHRIE
at 9.15

Leonard Rosoman, 'Danger, Men Working', Radio Times, 6th July 1951

REINGANUM, Victor (1907-95) Born in London, educated at Haberdasher's School, Hampstead; studied art at Heatherley's Art School and then in Paris at the Académie Julian. During this period he studied with Fernand Léger; began a distinguished free-lance career in 1926, contributing to *Radio Times* almost immediately. Worked in the scraperboard medium, in which he demonstrated superb precision and artistry.

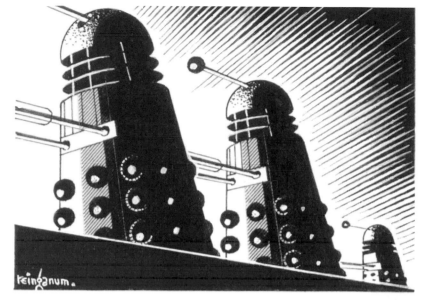

Victor Reinganum,
'The Evil of the Daleks',
Radio Times,
6th June 1968

ROBINSON, John (1916-97) Born in England but moved with his family to Australia at the age of 2. After his father's death his mother returned to relatives in the Isle of Man. Joined Merchant Navy; taken prisoner of war in Narvik, he escaped in a captured German launch with help from Norwegians. Later, during an Atlantic convoy, he was captured again and spent the remaining years of the war as a prisoner of war in Germany. After the war studied at Beckenham Art School. Contributed over sixty illustrations to *Radio Times.*

ROBINSON, William Heath (1872-1944) Born at Hornsey, Middlesex; educated at Islington and studied art at the Royal Academy Schools. One of three brothers, the others were Charles and Thomas, who became celebrated illustrators. He drew for the *Radio Times* in the late 1930s. One of the most popular of twentieth-century children's book illustrators; author/illustrator of *Uncle Lubin* and *Bill the Minder.*

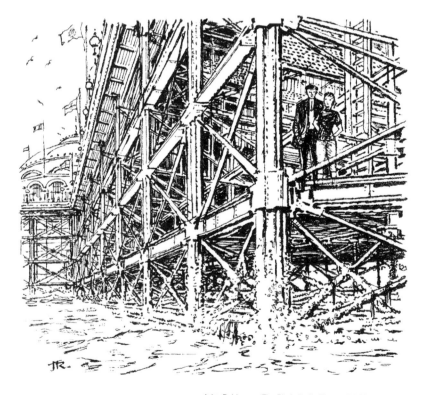

John Robinson, 'The Pier', Radio Times, 8th March 1957

PEAKE, Mervyn (1911-68) Born in China, came to England and attended Eltham College Academy Schools. Possessing the fantastic imagination of Richard Dadd, Peake developed a style as a writer and illustrator of bizarre originality. *Titus Groan, Gormenghast, Titus Alone* occupy a unique affection amongst devotees. Contributed to *Radio Times* in the late 1940s and early 50s.

PINN, Ingram (1950-) Grew up in Eastbourne. Studied painting at Camberwell School of Art (1968-72). Worked as teacher at a London comprehensive school, then as graphic designer at London University. First published drawing appeared in *New Society* magazine in 1975; commissioned to produce a drawing each week for *New Scientist* which he continued to do until 1995. Work commissioned by *Time* magazine, *The Times, The Sunday Times, The Observer*, and the *Financial Times*, to which he has contributed illustrations and political cartoons since 1987. Illustrator of four children's books featuring *Calm* a Welsh terrier, Weidenfeld and Nicolson (1987). His first *Radio Times* drawing appeared in 1978.

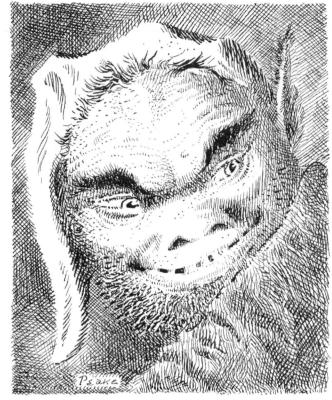

Mervyn Peake, 'Rumpelstiltskin', Radio Times, 1950s

POLLOCK, Ian (1950-) Born in Cheshire, son of Gordon Pollock, traditional claypipe manufacturer. Foundation at Manchester College of Art and Design; Studied at Manchester Polytechnic (1970-73); RCA (1973-76). Free-lance illustrator since the mid-1970's; work commissioned by most major magazines on both sides of the Atlantic; commissions include posters for the Royal Shakespeare Company; *King Lear* for Oval Projects; Paradise Lost for The Folio Society; postage stamps for Royal Mail (1997). Lecturer in colleges of art throughout the country. Awarded Honorary Degree of Doctor of Arts by Wolverhampton University (2001).

Ian Pollock,
'Amadeus',
Radio Times,
23rd January 1983

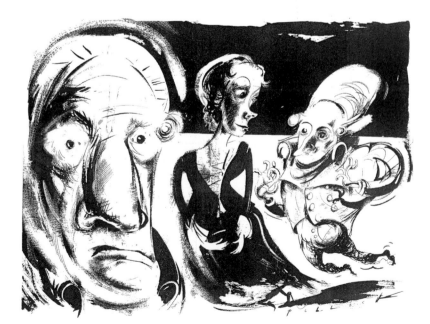

MINTON, John (1917-57) Born in Cambridgeshire; educated at Northcliffe House, Bognor Regis; Reading School, Berkshire; studied art at St Johns Wood Art School, (1935-38), and in Paris (1938-39). In collaboration with Michæl Ayrton designed the sets for *Macbeth* at the Piccadilly Theatre (1941). Taught illustration at Camberwell School of Art and Crafts (1943-46); Central School of Art and Crafts (1946-48); tutor at Painting School, RCA (1949-56). Contributed to *Radio Times* 1950s.

MOORE, Mona (1917-2000) Studied at St. Martin's School of Art and continued at the Central School of Arts and Crafts. During the war worked for the Recording Britain project. Commissioned by Kenneth Clark to make watercolours of the storage of National Gallery treasures in Welsh flint mine. Official war artist. First worked for *Radio Times* after the war, respected by Ralph Usherwood for always delivering her work on time.

OVENDEN, Denys W. (1922-) Keenly interested in natural history from childhood. Studied art at Hornsey College of Art; studies interrupted by service with Royal Engineers during WWII with postings to North Africa and Italy. Completed his diploma course on demobilisation. An authoritative illustrator of natural history subjects with commissions from *Radio Times* and other publishers, including Collins for *The Reptiles and Amphibians of Britain and Europe.* Fellow of the Zoological Society (1947).

John Minton, 'Sheba', Radio Times, 3rd December 1954

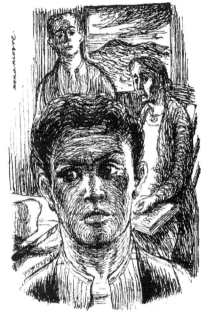

Mona Moore, Radio Times, 1950s

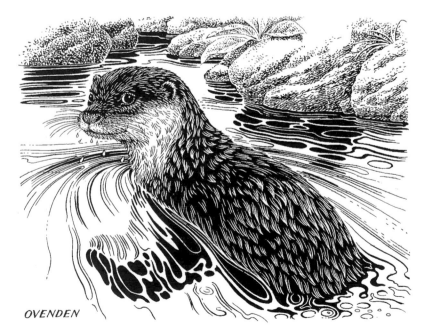

Denys Ovenden,
'Ring of Bright Water',
Radio Times, 1960s

OVENDEN

MASON, Robert (1951-) Born Isle of
Sheppey, Kent. Studied at Canterbury
College of Art from 1969. He then went to
Maidstone College of Art before attending
the RCA. He has combined a career in
illustration with teaching throughout the
UK and is currently head of illustration at
Norwich School of Art and Design. His
illustrations have been commissioned from
a wide variety of publishers. His research
project, *A Digital Dolly?, a subjective survey
of British Illustration in the 1990s,* was
published by NSAD in 2000.

McSWEENEY, Tony (1953-) Born in
Coventry and studied art at Lanchester
Polytechnic of Art and Design, Coventry
(1971-72); Liverpool Polytechnic School of
Art and Design (1972-75); RCA (1975-78).
Began working for *Radio Times* in 1978.
Visiting lecturer at Brighton, Chelsea,
Harrow, Kingston, Liverpool and
Newcastle Art Colleges, 1978-97. Member
of the Harrow College of Art Valediction
Panel, 1992 and 1998.

MELINSKY, Clare (1953-) Born at
Lancaster, educated in Norwich. Studied at
Central School of Art (1971-75). Moved to
Dumfriesshire in 1978. Began working for
Radio Times in that year and continued
until 1993. Commissioned by Royal Mail
to design set of stamps in 1997 and a
Christmas stamp in 1999. Works in the
medium of lino-cut.

MICKLEWRIGHT, Robert Flavell
(1923-) Born in Staffordshire, educated at
Balham; studied art at Croydon School of
Art (1939); Wimbledon School of Art,
(1947-49); The Slade (1949-52).First drew
for *Radio Times* in 1954. One of the most
oustanding artists commissioned by the
magazine. Elected MSIA (1955); FSIA
(1966 - resigned 1979); ARE (1961); RE
(1976); RWS.

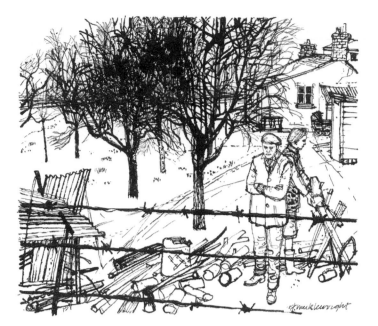

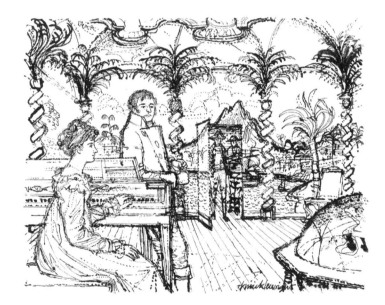

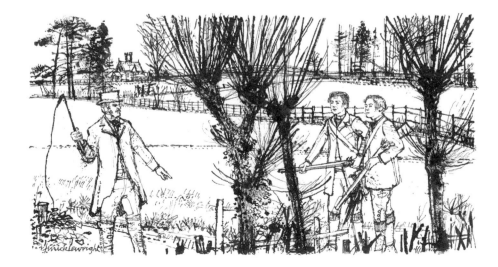

*Robert Micklewright.
From top,
'The Prisoner', 1960s
'Santa Cruz', 1969
'The Ordeal of Richard
Feverel', Radio Times,
1960s*

LEVETUS, Margaret (1919-) Born in London. Studied at the Central School of Arts and Crafts, London (1936-1940), and at Reading University Art Department. During WWII drove ambulances and did free-lance illustration work, mainly book-jackets; also two children's books for Noel Carrington, drawn on lithographic plates. From 1946-51 free-lance illustrator for various publishers; part-time tutor of wood engraving, life drawing and lithography at Sir John Cass College, London.

Margaret Levetus

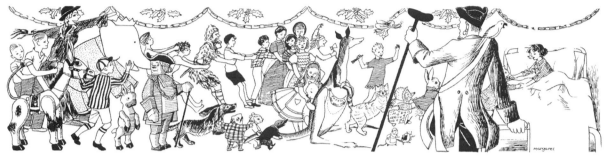

Margaret Levetus, 'The Chain', Radio Times, 22nd December 1950

LORD, John Vernon (1939-) Born at Glossop, Derbyshire. Educated at Rydal School; studied at Salford School of Art (1956-60); Central School of Arts and Crafts (1960-61). Tutor in illustration at Brighton Art College and the Polytechnic/University of Bighton (1961-99); Head of the Department of Visual Communication (1974-81), appointed Professor of Illustration in 1986. A children's book illustrator and author, mostly for Jonathan Cape, including *The Giant Jam Sandwich* and *Aesop's Fables* which won the W. H. Smith *Illustration Award*, (1990). Recently commissioned by The Folio Society to illustrate their forthcoming *Icelandic Sagas*. Awarded Honorary Doctorate by the University of Brighton (2000).

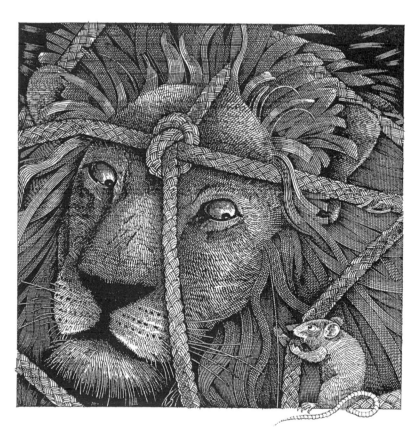

Professor John Vemon Lord

John Lord,
'The Lion and the Mouse',
Aesop 'Fables',
Jonathan Cape, 1989.
Illustrations winner of the annual
W. H. Smith Awards, 1990

KNOCK, Peter (1949-) Studied art at Southend School of Art (1968-69); Brighton College of Art (1969-72). Free-lanced from 1976 as illustrator, contributing to publishers in both UK and USA. First illustrated for *Radio Times* in 1976. Visiting lecturer at Maidstone College of Art since 1985, and Norwich School of Art since 1989.

LAPPER, Ivan, (1939-) Studied at Wolverhampton College of Art (1954-59), RCA (1959-62). Free-lance illustrator for advertising agencies and publishers. Taught at St Martin's School of Art, Ruskin School of Art, Oxford. Now one of Britain's leading historical reconstruction painters, working for English Heritage, CADW, and major museums in the UK and abroad.

LAWRENCE, John (1933-) Born at Hastings, East Sussex. Studied at Hastings School of Art (1951-53). After National Service joined the Central School of Art and Crafts (1955-57), studying wood engraving with Gertrude Hermes. Taught part-time at Maidstone College of Art (1958-60); Brighton College of Art (1960-68); Camberwell School of Art (1960-94). One of Britain's leading wood engravers, his work has been commissioned by The Folio Society and other publishers of fine books. Although Lawrence did not receive commissions from *Radio Times*, he contributed work to BBC Publications.

LAWSON, Carol (1946-) Born at Giggleswick, Yorkshire. Studied art at Harrogate College of Art and at Brighton College of Art until 1967. Free-lance illustrator and lecturer in visual communication, Brighton College of Art, 1976-81. Author and illustrator of many children's books, most recently *The Upstairs Downstairs Bears* which has also been made as an animated children's TV series. Her first *Radio Times* commission was for a Christmas cover in 1983.

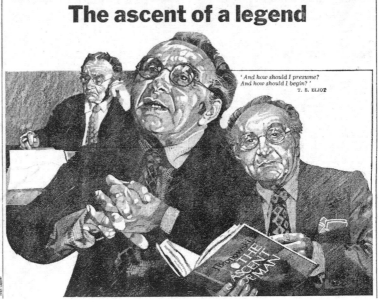

Ivan Lapper, 'The ascent of a legend', Radio Times, 29th May 1975

John Lawrence, 'Malvolio', From The Folio Shakespeare, 1988

JACQUES, Robin (1920-95) Born at
Chelsea, London; left school at 15 with no
formal art training and joined an
advertising agency. After service during
WWII he became a free-lance illustrator;
art editor for *Strand Magazine*; worked for
Central Office of Information (1948-51).
A prolific and popular illustrator - one of
the twentieth-century's finest graphic
artists, commissioned by most leading
publishers, including The Folio Society.
An enthusiast for jazz and modern art. He
began working for *Radio Times* in 1946 and
continued until shortly before his death.

Robin Jacques, 'Come Along to Freedom', Radio Times, 10th August 1961

JAQUES, Faith (1923-97) Born at
Leicester; educated at Wyggeston School
for Girls; studied at Leicester School of Art
(1941-42); served in the WRNS during
WWII where she was posted to Oxford,
continuing to study at evening classes at
Oxford School of Art; returned to full-time
art education at the Central School of Arts
and Crafts (1946) and sold work while still
a student. Faith Jaques' success as one of
Britain's most popular illustrators was
consolidated when she was selected as
illustrator for the English edition of
Charlie and the Chocolate Factory (1968).
Her last work was *The Orchard Book of
Nursery Rhymes* (1989). Fiercely
independent, Faith Jaques vigorously
fought for illustrators' rights in respect of
fees and copyright. She contributed
illustrations to *Radio Times* from the early
1960s.

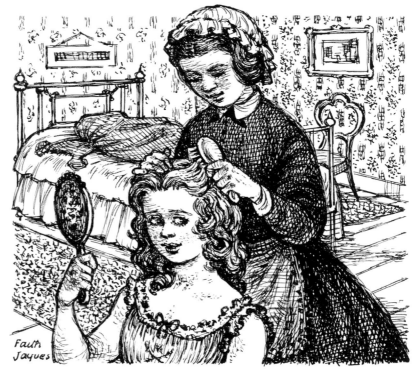

Faith Jaques, 'Secrets', Radio Times, 1959

KAUFFER, Edward McKnight (1890-
1954) Born in Great Falls, Montana, USA;
added name of McKnight in gratitude for
the patronage of his benefactor, Joseph
McKnight, a professor at the University of
Utah; studied art at night classes in San
Francisco, then at the Art Institute of
Chicago and in Munich; after two years in
Paris he settled in London early in 1914.
He began poster designing with
Underground Railways; one of the most
influential figures in graphic design
between the wars; work on show in
London and Washington DC; exhibited,
Ashmolean Museum, Oxford, (1926); New
York Museum of Modern Art, (1937).

KNIGHT, David (1923-82) Born in
Surrey. His studies at Wimbledon School
of Art were interrupted by service in the
army during WWII. He then worked as an
art editor of a magazine for three months
before becoming a free-lance illustrator. He
began working for *Radio Times* shortly
after and also illustrated many books. He
had a particular skill in architectural
drawing, depicting vivid ærial views of
cities and towns.

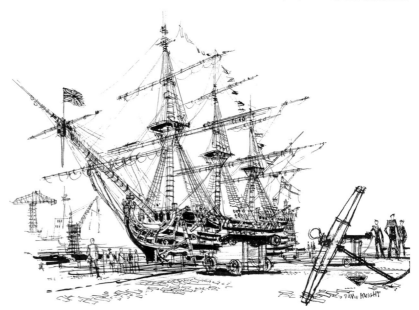

David Knight, HMS Victory, 'Friday Night is Seaside Night,', Radio Times, 29th July 1965

HODGES, Cyril Walter (1909-) Born at Beckenham, Kent, educated at Mount Pleasant School, Southbourne; left at 13; completed his formal education at Dulwich College; at 16 he went to Goldsmiths' School of Art, where his fascination for theatre design absorbed his studies; first worked for The Everyman Theatre; he then joined the advertising agency G. S. Roydes and began free-lancing as an illustrator, represented by R. P. Gossop, soon receiving his first commission for *Radio Times*. In a distinguished career he has combined his skills in drawing and writing. In parallel with these he is an acknowledged expert on Elizabethan theatre, working with the late Sam Wanamaker to realise the actor's dream of recreating Shakespeare's *Globe* on London's South Bank. He taught illustration at Brighton College of Art (1959-69).

HOFFNUNG, Gerard (1925-59) Born in Berlin, came to London in 1938. Studied at Hornsey and Harrow Schools of Art. Art Teacher at Harrow (1945-50). Staff artist at *Evening News*. Cartoonist and illustrator, broadcaster and musicologist - producing the celebrated series of *Hoffnung Festival Concerts* at London's Festival Hall, in the 1950s.

C. Walter Hodges, editorial title page illustration, Radio Times, December 1934

John Ireland, self-portrait, 2002

IRELAND, John (1949-) Born at Aldershot. Educated at Farnham Grammar School (1960-66); studied at Farnham Art School (1966-68); Ravensbourne College of Art & Design (1968-71); Dip. AD in Graphic Design. Failing to find a job in design he drifted into illustration. Moved to Norfolk in 1976. First commission for *Radio Times* was in August 1973; worked regularly for the magazine until 1993. Influenced by Ronald Searle, Nicolas Bentley, David Low and Rowland Emett.

Drawings by Gerard Hoffnung
included in exhibition catalogue
designed by Harold Cohen

GREER, Terence (1929-) Born in Surrey; studied at Twickenham School of Art; National Service in RAF for two and a half years from 1947; returned to study at St Martin's School of Art and Royal Academy Schools; free-lance on leaving college. In the 1970s he changed career from illustrator to playwright, a *Dr Who* series is credited to him.

GRIMWOOD, Brian (1948-) Studied at Bromley Technical High School with Owen Frampton who ran a unique three-year graphics course. He left full-time education in 1964 and joined Pye Records. After five years working for various advertising agencies and design groups as an art director and designer he became a free-lance illustrator. He has travelled extensively in the Far East lecturing in Singapore, Australia and Japan. In 1983 he founded the CIA illustration agency.

GROSS, Anthony (1905-84) Born in London, the son of a map publisher; initially studied at the Slade School of Fine Art, then took a part-time course in etching at the Central School of Arts and Crafts; studied in Paris at the Académie Julian and the Ecole des Beaux Arts. Created film animations, including *The Fox Hunt* (1934-36) for Alexander Korda; illustrated Jean Cocteau's *Les Enfants Terribles* (1936). Official war artist (1941-45). First illustrated for *Radio Times* in 1951. Taught at the Central School of Arts and Crafts (1941-51). Elected RA (1980); C.B.E (1982).

HARRIS, Derrick (1919-60) Born at Chislehurst, Kent. His family moved to Angmering, West Sussex and he attended Worthing Art School. During the war he studied at Saint Martin's School of Art and then enrolled at the Central School of Art. Free-lanced as a wood engraver, working for many publishers of fine books, notably The Folio Society and Golden Cockerel Press, he also greatly enjoyed working for *Radio Times*. He taught at Kingston School of Art during 1947 and at Reigate School of Art in 1955.

HILDER, Rowland (1905-93) Born in New York State of British parents, Hilder came to England with his family in 1915. He studied etching and drawing at Goldsmiths' College (1921-24). From 1925 he free-lanced as an illustrator. During WWII he served as a camouflage officer, then as illustrator at the Central Office of Information. He set up the Heron Press to publish his landscape paintings and, when Royle took over in 1963, he was able to devote himself full-time to painting. Awarded O.B.E. in 1986. PPRI; RSMA.

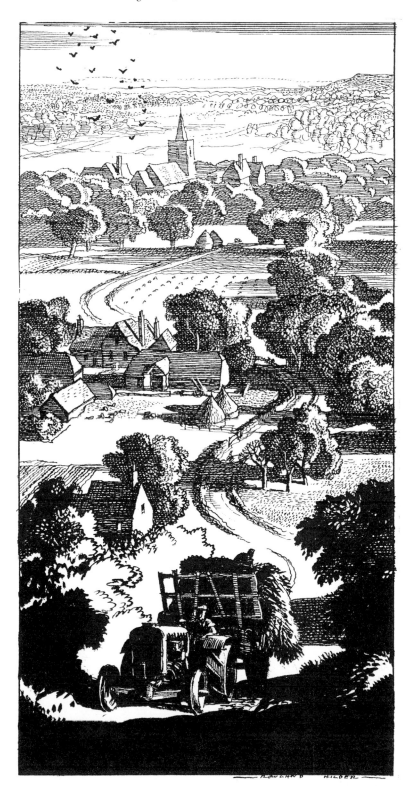

Rowland Hilder, 'This Land is our Concern', Radio Times, 15th September 1944

FRASER, Eric (1902-83) Born in London, studied at Westminster School of Art (with Walter Sickert) while still a boy, then at Goldsmiths' College (1919-24). Exhibited at the Royal Academy (1923). He taught figure composition and commercial design at Camberwell School of Art (1928-40). Contributed to *Radio Times* from 1926 until 1982. An artist who developed one of the most personal and instantly recognisable styles, he created illustrations for a variety of publishers, including The Folio Society and the *Everyman Classics* bookjackets for Dent. His work was also commissioned by advertising agencies, an early success was his creation of *Mr Therm* for the Gas, Light & Coke Company. Fraser also painted, contributing murals for the *Festival of Britain* in 1951, and posters for London Transport, Shell, the GPO and Guinness.

GENTLEMAN, David (1930-) Born in London. Studied at St. Albans School of Art (1947-48) and RCA (1950-53) under John Nash and Reynolds Stone. Taught at RCA for two years on graduating. Became free-lance artist in 1955 working in a variety of mediums, from watercolour to wood engraving. His most ambitious project, demonstrating his flexibility as a designer, is the 100 metre mural made for the Northern Line platforms at Charing Cross underground station in 1979.

GILBERT, Anthony (1916-95) Born at Leamington Spa. Studied at Goldsmiths' College of Art. Began free-lancing as illustrator from the age of 18. Contributed to *House and Garden, Strand, Housewife, Lilliput* and *Vogue*. Worked at J. Walter Thompson advertising agency where he designed the *After Eight* packaging. Married to Ann Buckmaster.

GRAY, Lynda (1947-) Born in Essex. In 1948 her family moved to Shanklin, Isle of Wight. Completed foundation year at Portsmouth College of Art, then studied at Leicester Polytechnic under Andre Amstutz and Edward Bawden. In 1971 she moved to London and began working for *Radio Times*. Commissions followed from *Cosmopolitan, Daily Mail, The Times, The Sunday Times, Illustrated London News, Nova* and *The Post Office* - a set of stamps issued at Christmas (1986). Her subsequent career has been as a successful fine artist, working in the medium of lino cut and collage.

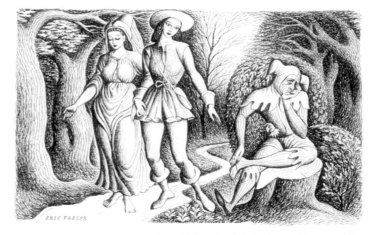

Eric Fraser, 'As You Like It', Radio Times, 1st September 1944

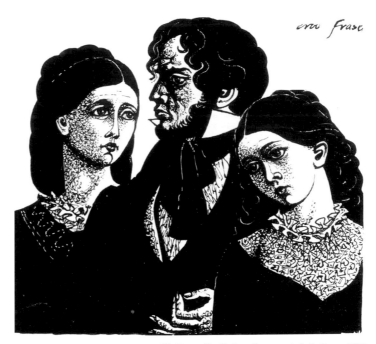

Eric Fraser, 'The Brothers Karamazov', Radio Times, 1957

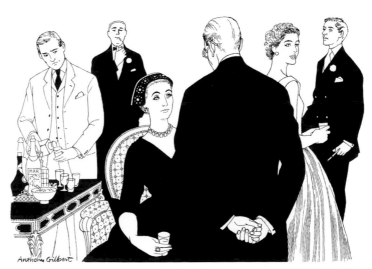

Anthony Gilbert, 'The Cocktail Party', Radio Times, 1950s

ELLISON, Pauline (1946-) Born at Keighley, Yorkshire; educated at Keighley Grammar School; studied at Bradford and Cambridge Art Schools, where David Driver was one of her tutors. Moved to London in 1967 and began a free-lance career. First worked for *Radio Times* in 1969. Commissions include work for *Harpers, Good Housekeeping, Nova, The Observer, The Sunday Times*; illustrated several books, including Grimm, *Fairy Tales, Master Maid* (USA). Noted packaging designer for Marks and Spencer, Crabtree and Evelyn, Estee Lauder, Ian Logan. Lately working with website designers on animated interiors. Exhibited at Bologna Book Fair and Annapolis, USA.

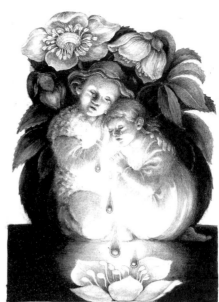

Pauline Ellison, 'The Christmas Rose', Radio Times, 23rd December 1979

Hannah Firmin, 'The English Seaside', Radio Times, 1970s

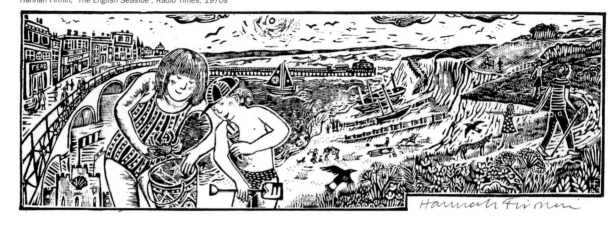

FIRMIN, Hannah (1956-) Born in Battersea, London. Hannah's family - her father is the popular children's illustrator, Peter Firmin - moved to Blean, near Canterbury in 1959. Studied at Chelsea School of Art and RCA, being taught drawing by Susan Einzig and Roy Spencer at Chelsea, and Linda Kitson at the RCA. She began working for the *Radio Times* in about 1981. One of Britain's finest engravers and print makers; commissioned by The Folio Society to illustrate *Folk Tales of the British Isles* (1985).

FIRMIN, Peter (1928-) Studied at Colchester Art School (1944-47). After National Service in the Navy, studied at the Central School of Art. Worked in stained glass, advertising and magazine illustration. With Oliver Postgate created the characters for *Ivor the Engine, Clangers, Bagpuss and Noggin the Nog* for television. Author and illustrator of the *Noggin* series, *The Winter Diary of a Country Rat*, and *Midsummer Diary of a Country Rat*. He also engraved illustrations for Vita Sackville-West's *The Land and The Garden*.

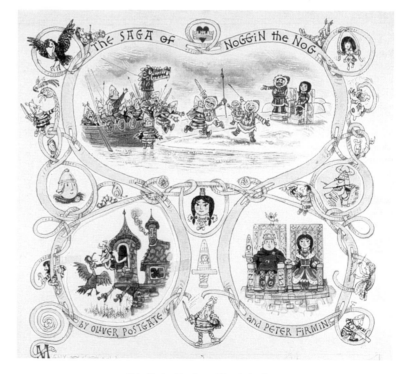

Peter Firmin, 'The Saga of Noggin the Nog', Radio Times, 22nd August 1968

EINZIG, Susan (1922-) Born in Berlin; came to England in April 1939 and studied at the Central School of Art and Design, first in London and afterwards, during the war, in Northampton. Conscripted into war work in 1942; started to free-lance in 1945, illustrating for *Picture Post, Lilliput, Radio Times* and other well known magazines. Illustrated books for OUP, Bodley Head and others. *Tom's Midnight Garden*, published in 1959, won the Carnegie Medal. Began teaching at Camberwell School of Art in 1946, where her close colleagues included John Minton and Keith Vaughan. Taught at Chelsea School of Art from 1959 until 1987 as senior lecturer in drawing and illustration. An outstanding painter - her portrait of John Minton is possibly the most revealing likeness of his brooding and charismatic personality. Contributed work to *Radio Times* from about 1948, her work informed by an intense awareness of literature and history.

Susan Einzig,
'Iron Curtain',
Radio Times, 1952

FAY COMPTON IN

'The Tragedy of Nan'

BY JOHN MASEFIELD

Jenny Pargetter..........Betty Linton
Mrs Pargetter.Nan Marriott-Watson
Mr. Pargetter.. ...Hugh Manning
Nan Hardwick............Fay Compton
Dick GurvilBrian Wilde
Gaffer Pearce.........Patrick Wymark
Artie Pearce..................Bob Arnold
The Rev. Mr. Drew.Leigh Crutchley
Captain Dixon............John Dearth
OTHER PARTS PLAYED BY
Bernara Hepton, Peter Wilde
and Emma Young

PRODUCED BY R. D. SMITH
in the BBC's Birmingham studios

at 9.15

The tragic story of the orphaned girl Nan Hardwick is set in a west-country farmhouse in the year 1810.

Susan Einzig, 'The Tragedy of Nan', Radio Times, 13th June 1958

DINSDALE, Mary (1920-?) Born at Guildford; studied at Guildford School of Art (1936-9). War service as engineering draughtsman; contributed to *Lilliput*, *Radio Times* and *Strand* magazine. Illustrator of many childrens' books.

DRIVER, David (1942-) Studied at Cambridge School of Art (1959-63) under Paul Hogarth and Owen Wood. Represented by Saxon Artists as free-lance illustrator before moving to the Thomson organisation as editorial designer. Joined IPC as assistant art editor of *Woman's Mirror*. Appointed art editor of *Radio Times* in 1969 and art editor and deputy editor in 1975. Joined *The Times* in 1981, as head of design and in 1986 was given the additional title, assistant editor. Doctor of Letters, Anglia University, 2001. One of the most influential editorial designers of the 20th century.

Mary Dinsdale, 'Imperial Palace', Radio Times, 6th March 1959

DODDS, Andrew (1927-) Born at Gullane, Scotland; joined the junior art department of Colchester School of Art; in 1943 he moved to the senior school to complete the full-time National Diploma in Design course until he was called up into the Navy. In 1947 he enrolled at the Central School of Arts and Crafts, studying with Bernard Meninsky and John Minton; first commissions were for *Eagle* and *Farmer's Weekly*; first illustration for the *Radio Times* appeared in 1951 for the series *The Archers* (he used his mother as a model for Doris). Contributes work to the Eastern Daily Press and does book illustrations; visiting tutor in illustration at St. Martin's School of Art (1951-72); retired as deputy head of Suffolk College School of Art and Design in 1989.

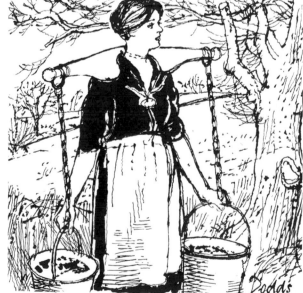

Andrew Dodds, 'The Fallow Land', Radio Times, 26th January 1961

BRANGWYN, Sir Frank (1867-1956) Born in Bruges; his family returned to London in 1875. Art training began in his muralist and architect father's studio; early talent attracted the attention of established artists and, at the age of 15, he began working for William Morris. He submitted a painting to the Royal Academy Summer Exhibition and was accepted, aged 17. He travelled throughout the world, his work influenced by Orientalism, and, though shamefully neglected in Britain, he gained a reputation as a modernist in Europe. Brangwyn was one of Britain's finest twentieth-century painters and etchers. He died in Ditchling, Sussex, the village which was also home to Eric Gill and many other important artistic figures.

BROOKES, Peter (1943-) Born in Liverpool; educated at various schools around the UK where his father was stationed in the RAF; initially studied at Manchester School of Art then at Central School of Art and Design from 1966; free-lance from 1970; taught at the Central School of Art and Design, 1976-78 and at the RCA from 1978; regular contributor to *Radio Times* and *The Listener* from the early 1970s. Now contributes a regular cartoon for *The Times*. Awards include Political Cartoonist of the Year, British Cartoon Awards, 1996, 1998 (Runner-up 1995, 1997, 1999, 2001) and three British Press Awards nominations in 1996, 2001, 2002. Member of Alliance Graphique International; FRSA.

BROWNFIELD, Mick (1947-) After foundation year at Walthamstow College of Art, studied at Hornsey College of Art with Martin Leman (1966-69). While developing a portfolio of illustration work he became a cleaner for a year, then joined a design group in Kensington. He left to free-lance as an illustrator in 1973, and received his first *Radio Times* commission in 1975. He contributed the first of many *Radio Times* covers in 1979. In addition to work for other major newspapers and magazines he has worked regularly for *Radio Times* for over twenty-one years.

BUCKMASTER, Ann (1924-) Born in London, studied at Beckenham School of Art and Bromley School of Art. Worked at J. Walter Thompson advertising agency. Contributed illustrations and fashion drawings for magazines and advertising. Married to the late Anthony Gilbert.

CHAPMAN, Gaynor (1935-2000) Born in London. Studied at Epsom School of Art, 1951-52, Kingston School of Art (1952-55); RCA (1995-58). Retained by Thames and Hudson for two years whilst working on the seminal *The Dawn of Civilisation*, published in 1961. Free-lance illustrator for London Transport, Shell, COI, American Express. Illustrated several books, including, Grimm, *The Luck Child* (1968), runner-up Kate Greenaway Medal; *Aesop's Fables*, (1971).

CHURCH, Caroline (1962-) Studied at Chelsea School of Art and, as guest student, at Royal Academy Schools, studying wood engraving (1985). First worked for *Radio Times* in 1988. A distinguished scraperboard artist commissioned by many companies and publishers.

COSMAN, Milein (1921-). Born in Germany; studied at the International School of Geneva. She came to England in 1939 and went to The Slade School of Fine Art. Later she gave lectures on art for WEA and a course on art and drawing for ITV. The first conductor she drew was Sir Henry Wood at a concert at the Queen's Hall in London during the blitz. Douglas Græme Williams commissioned her first drawing, of Constant Lambert, for *Radio Times* in 1946. Married to Hans Keller, the BBC's head of chamber music and head of orchestral music from 1959-1979. Publications include *Musical Sketchbook*, Cassira, Oxford; *Stravinsky 'Seen and Heard'*, Toccata Press; works in numerous private and public collections including the V&A and the National Portrait Gallery.

Milein Cosman,
'Sir Thomas Beecham',
Radio Times,
17th October 1947

BIRO, Val (1921-) Born in Budapest and educated there by Cistercian monks. After early art training in the studio of Almos Jaschik, he settled in England in 1939 where he enrolled at the Central School of Arts; art director for John Lehmann Ltd (1946-48). From 1948 worked as free-lance artist and author of children's picture books, notably the *Gumdrop* series published by Brockhampton Press and Hodder and Stoughton. He contributed regularly to *Radio Times* from 1951 until 1972. FSIA.

Val Biro, 'The Dynasts', Radio Times, circa 1970

Val Biro, 'Die Walküre', Radio Times, circa 1970

Val Biro, 'Falstaff', Radio Times, circa 1970

BOSWELL, James, (1906-71) Born in New Zealand. First studied art at Elam School of Art, Auckland, then at RCA (1925-29). Political activist as a result of his experiences during the Depression, joining the Communist Party in 1932. With James Fitton and James Holland contributed to *Left Review*. During the war served in the RAMC. Art editor of *Lilliput* (1947). From 1951 worked as a painter and illustrator; designed the publicity for the Labour Party's successful election campaign (1964); taught at Brighton College of Art; autobi- ography: *The Artist's Dilemma* (1947).

James Boswell, 'Memoire of Mrs Cramp', Radio Times, 28th September 1956

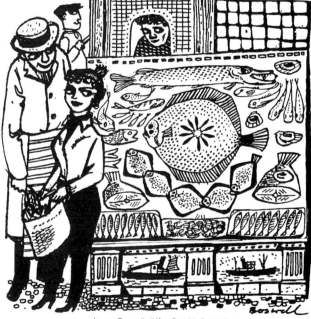

James Boswell, 'Life : Death', Radio Times, 19th March 1964

The Artists

Victor Reinganum,
'Andy Pandy',
Radio Times,
26th January 1951

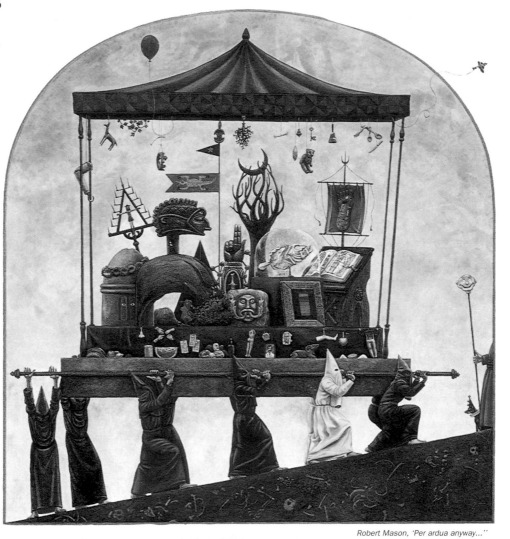

Robert Mason, 'Per ardua anyway...''

Ingram Pinn

Ian Pollock

John Robinson

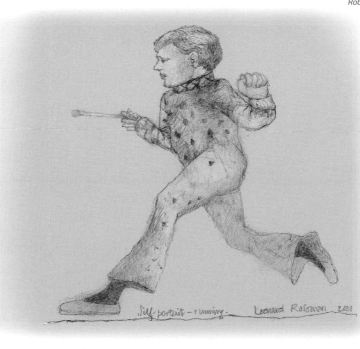

Leonard Rosoman, self-portrait - running, 2002

Barry Wilkinson

Janet Woolley

Paul Slater

Left to right facing camera: Grace Williams, Edward Ardizzone, Peter Harle, C. W. Bacon, Jack Dunkley, Victor Reinganum, Eric Fraser and others at reception during an exhibtion of their work. Broadcasting House, London, 1980s. Copyright BBC.

Janet Archer Mick Brownfield Caroline Church Milein Cosman Pauline Ellison Hannah Firmin

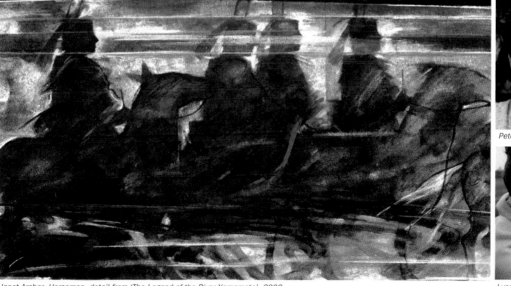

Peter Firmin

Janet Archer, Horsemen, detail from 'The Legend of the River Yamamoto', 2002 Lynda Gray

Ivan Lapper Carol Lawson Tony MacSweeney Robert Mason Robert Micklewright Mona Moore

A Student at the Central School of Arts & Crafts, 1936 - 1940

Margaret Levetus

IT WAS RATHER DAUNTING AT FIRST; this big building on the corner of Southampton Row and Parton Street. You went up the steps, through the big, glass-panelled door, past the porter's little office on the left, into the hall with that funny, squat pillar in the middle.

My student's card, which was also my timetable, had been made out by Mr Rooke, who was head of the book production department. It said I was to do general drawing on Mondays, lettering on Wednesdays and book illustration on Fridays. On Tuesdays and Thursdays, he had advised, I should visit museums and art exhibitions, and continue as much as possible with my general education.

Monday, September 28th, 1936, the first day of term. I was seventeen and had left school in July. The room marked "General Drawing" was full of plaster casts.

On Wednesday September 30th, I went to the lettering room on the second floor. In the morning we discussed the lettering on the new stamps. The letters had rather rounded ends, and I thought it looked as though they had been squeezed out of a tube, like tooth-paste. I suppose the style suited the blunt, smooth features of King Edward VIII, but I should have preferred something rather more clear-cut. However, it didn't matter much, since the stamps would soon have to be changed. On a foggy evening ten weeks later, I came out of the Central School to the sound of a barrel-organ, and the whine and rattle of

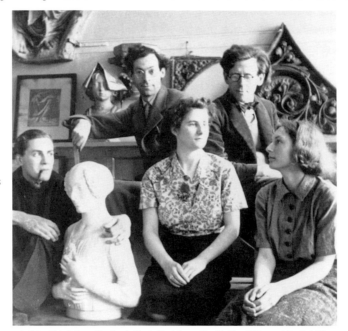

Left to right: Anthony Froshaug, Morris Kestelman, Eve Sheldon Williams, John Farleigh, Margaret Levetus. Courtesy Central Saint Martin's Museum Collection.

trams going into the tunnel to Kingsway, and read an *Evening News* placard: "King Abdicates - Official".

On Friday, October 2nd I went to my first book illustration class. There was constant quiet bustle and movement. Mr Rooke was there, in his grey suit, with his short grey beard; neat, brisk and businesslike, but never submitting to L.C.C. bureaucracy. I noticed that, on the register which we all had to sign each day, the teacher in charge had to state whether the instruction was 'collective' or 'individual'. Rooke had written boldly: "collective and individual."

Besides Mr Rooke, there were usually two other teachers: John Farleigh in his corduroy jacket, who taught illustration and wood engraving, and Hal Missingham, dark-bearded, in a dark green suit, teaching commercial art.

Draped life took place in the womens' life room, just across the passage from the illustration room. In those days, the sexes were segregated for life drawing, which meant the model was nude.

Morris Kestelman, was a very skilful draughtsman and an exceptionally good teacher, "Try doing this one in pen-and-wash," he'd say, indicating the *Discobolus*, or, "Have a go at a scene through the window in water-colour." On one memorable occasion, he suggested, "Try to draw this as though you were looking at it from the back." At last I was helped to understand the important fact that drawing wasn't just copying the forms in front of you, but

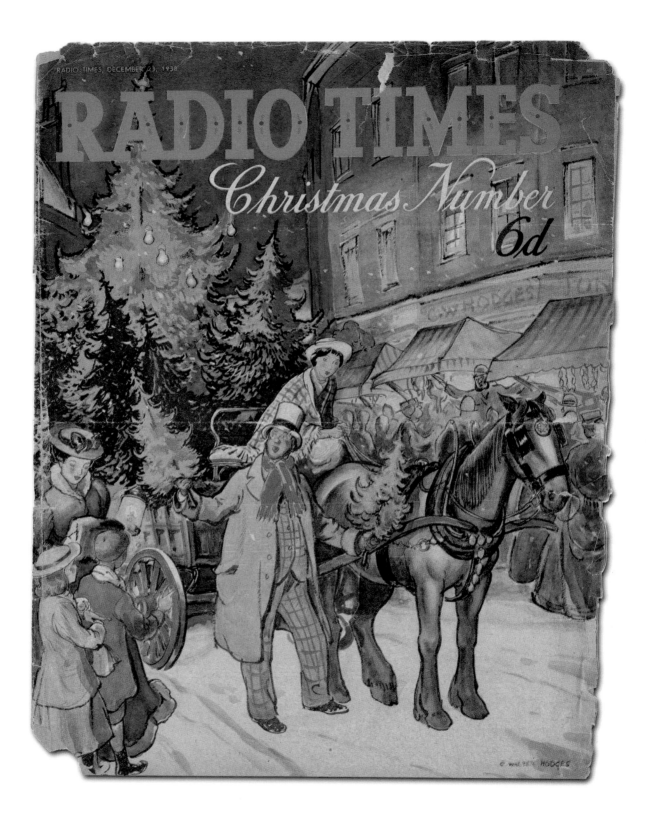

RADIO TIMES, DECEMBER 23, 1938

RADIO TIMES
Christmas Number
6d

C. Walter Hodges,
Radio Times, cover,
Christmas, 1938

editing and designing the pages a facility denied earlier typographers, designers and editorial writers.

The first issue of *Radio Times* providing comprehensive details of UK broadcasts by the BBC and independent companies appeared in March 1991. The additional information meant that illustrations, on the listing pages at least, were relegated to small 'postage stamp' sized miniatures, or the bleed areas of pages. Hand crafted work with æsthetic integrity gradually gave way to images where style subverted substance or those created digitally. However, illustrations by Mick Brownfield, Bill Sanderson, Paul Slater and Janet Woolley are now making frequent, welcome, appearances. In 1992, after forty-two years, *Radio Times* moved from the somewhat ramshackle building in Marylebone High Street to modern premises at White City in West London. Circulation during the 1980s had consistently achieved figures of above three million copies a week and in 1988 one issue even achieved a peak of over eleven million copies, and was given the accolade as the biggest selling edition of any publication in British history by the *Guinness Book of Records*. Sales fell throughout the nineties until, by 1999, net sales had dropped to only 1.3 million. Even today, however, *Radio Times* is the only magazine to give the most complete details of television and, especially, radio programmes for the UK. There is also an electronic version on the internet at *www.radiotimes.beeb.com*.

A redesign in April 2001 resulted in the masthead '*Radio Times*' being changed to a Gill sans serif, matching, though not deliberately, the Corporation's own change to this font for its house style. The letter spacing of this highlights one of the pitfalls that computer programmes like *Quark Xpress* and *Pagemaker* present to designers - just because things *can* be done with them does not mean that they *should* be done. Listing pages were also formatted to include Gill for headings and Franklin Gothic for the text, a typographical tautology - though Franklin is a highly legible font for text, the mixing of these two sans serif faces creates an uncomfortable visual dissonance.

For over sixty years, from its launch in 1923, until the mid-1980s, *Radio Times* nurtured the genre of narrative illustration into a final flowering, the craft of which has largely been made redundant by the ineluctable paint-by-numbering of computer programmes. This technology has democratized the creation of images, however, those who use it do so mostly from a background of technology rather than the arts. An understanding of physics does not equip them to re-create, still less realise the magic of the subtleties of light, form, or aerial perspective and the results echo Maoist collectivism - an amusing slant given the capitalist thrust of the technology - being an amalgam of the skills of a multitude of programmers in addition to the user. There is no intrinsic individuality in computer image creation. For the moment there is more vitality and beauty in a single line in any of the works by the artists represented in this exhibition than in a whole image created by digital means. *Martin Baker*

Mick Brownfield,
(above) Radio Times, cover,
Christmas, 1996
(right) 'Bruce Forsythe and
Ronnie Corbett', 1988

says, he was taught to draw accurately. He then went to Maidstone College of Art to study graphic design. Towards the end of the course he considered giving up his studies and a career in art. William Stobbs, the Principal, and an outstanding illustrator himself, stopped him on the stairs and urged him to continue, and to sell his work in London. Following a year out he went to the Royal College of Art to study illustration. He has since been in continuous demand, contributing paintings to newspapers, magazines, advertising campaigns and, on one occasion, for a film, supplying two enormous canvasses for *The Witches of Eastwick*. His first commission for *Radio Times* was published in 1986, a cover for the series *Artists and Models*. He contributed the covers for the Christmas editions in 1991 and 2001 and his work still features in the listing pages. He was the Association of Illustrators, *'Illustrator of the Year'* in 1996. Slater, undoubtedly one of today's finest artists, irrespective of 'commercial' or 'fine art' labels, always works in colour, producing work that shows a truly fantastic imagination allied with a masterful use of traditional techniques.

End of Monopoly, and of an Era

From 1st March 1991, Section 176 of the Monopolies and Mergers Commission was implemented and *Radio Times* appeared with details not only of BBC programmes, but also the two independent terrestrial channels. Digital channels were also included. Roger Hughes, recently retired as managing editor of *Radio Times*, remembers the transition, "The ending of the listings 'duopoly' was a long time coming, and when the hammer finally struck the magazine was well prepared. Nicholas Brett's appointment as editor in 1988 was specifically to prepare the magazine for competition. Nevertheless, four-channel listings (plus those for the new-fangled satellite channels) were a new world to us. We brought in a couple of staff from *TV Times* familiar with the commercial sector who advised us how they worked (rather differently from the BBC). At the end of 1990 I and one of our research team embarked on a programme of get-to-know-you visits to all the ITV companies, establishing new lines of communication and building a relationship of trust. Trust was indeed the issue for many years. *Radio Times* remained, after all, a BBC magazine, and there was naturally some concern among the BBC's competitors

that they were now required to hand over sensitive programme and scheduling information to 'the other camp'. Staff were warned to be strictly impartial, and to handle all programme information in the strictest confidence. Our rule was that we did not deem scheduling information from either side to be in the public domain until *Radio Times* was on the streets. The BBC side was discouraged from asking us about 'what we knew' on the basis that if we could be relied upon to pass them ITV secrets, could they be certain we would not ingratiate ourselves with ITV by betraying those of the BBC? We played a straight bat. Some ITV companies embraced the change and opened up channels of communication without delay. Some remained as dinosaurs for several years: finding out information about their programmes was difficult for a long while. Ironically, our relationship with *TV Times* was good, and pragmatism determined that we could usefully help each other out in such circumstances. It must be said that many BBC programme-makers had trouble changing their ways, too: they had for all their BBC careers had a direct relationship with *Radio Times*, and many had to be reminded that they should now deal with a third party, who would make their information available to both *Radio Times* and *TV Times* at the same time. To cope with the additional channels, *Radio Times* listings virtually doubled in number, at least initially, to cope with the impact.

"Readers wrote before deregulation to ask what the cover price would be once we doubled the number of channels we listed. They hoped we would not abuse our position and charge more than the previous 50p. In the event, a price increase was placed out of the question by the arrival on the scene of price-cutting, cheap-and-cheerful alternatives. Despite holding our price to 50p, raised cautiously to 55p after six months, circulation almost halved as a result of competition. *Radio Times* sold 2.89 million copies in the last full half-year before deregulation (Jul-Dec 1990); two years later this was 1.59m. The plethora of titles in the marketplace has made this inevitable. Before deregulation there were 3.1 million people buying between them 5.7 million copies of the two available titles, today the paid-for listings market accounts for about 5.1 million copy sales each week."[46]

The Art Department was equipped with Apple Macintosh computers in 1989, giving the work of

Paul Slater,
'Sherlock Holmes',
Radio Times, cover,
5th December 1987

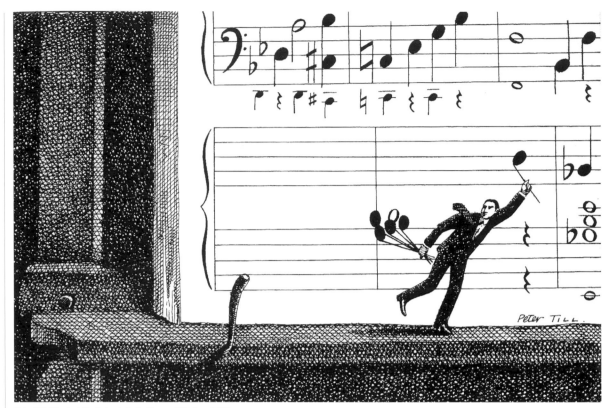

Peter Till, 'Musical Plagiarism', Radio Times, 27th June 1982

Radio Times, which he began working for in the mid 1970s. At one time he augmented his career as an illustrator with appearances on the alternative comedy circuit, once with a weekly six month run at the *Comedy Store* in London.

A notable trend emerged at this time, that of pastiche. Mark Thomas transformed the art of comic strip to create almost film-noirish dramatisations for his illustrations. He began working for *Radio Times* in about 1976 and will be remembered for the powerful images he created for the title sequence of Denis Potter's *The Singing Detective* in 1986. He nearly missed the opportunity to create the *Radio Times* cover for this feature as he was away on honeymoon when art editor Brian Thomas telephoned him. Fortunately the message was retrieved from his answerphone just as Brian Thomas was about to approach other illustrators.

Mick Brownfield refashioned the style of American pulp magazine art of the 1940s and 50s, once considered facile and representing the worst aspects of commercial art, making it transcendentally guileless. Possessing a remarkable ability for creating stunning hand-drawn typographic effects, his skill and affection for the vernacular originals is imbued with a nostalgia that made him the ideal choice as illustrator of a record

six Christmas covers, in 1990, 1992, 1993, 1995, 1996 (p.62) and 1998. In a break from tradition, he painted the cover for the 2001 Christmas edition of *TV Times,* remarking that he felt disloyal doing it!

Brownfield remembers that while searching for packing material in which to send off his 1996 Father Christmas cover, he went to make a cup of tea. On returning to his studio he spotted the ideal material lying on his studio desk. He cut the board in half discovering, with horror, that he had sliced his artwork in two, turned face down while he left the room. He had to stick the two halves together and carefully retouch the cut.

The importance that *Radio Times* attaches to the covers, especially for the Christmas and New Year issues cannot be overestimated and illustrators submit many roughs until a final image is chosen.

The distinction between the artist as either 'illustrator' or 'painter' is confounded by the work of Paul Slater. He is a superlative painter - greatly admired by his peers and also by the fine artists. He understands and respects the medium of oil or acrylic pigment, and his paintings exhibit all the bravura qualities of Frank Brangwyn. He initially studied at Burnley Technical College from 1969-71 where, he

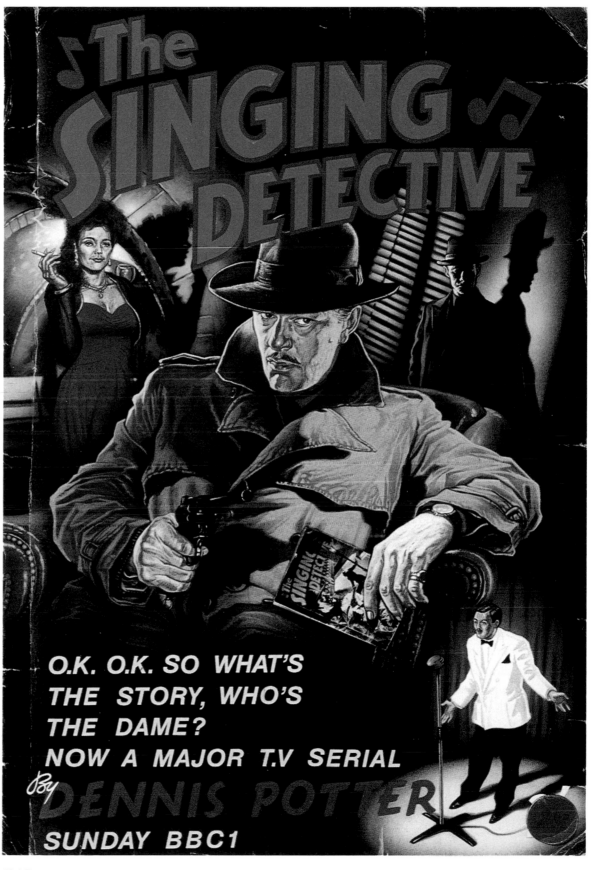

Mark Thomas,
'The Singing Detective',
Radio Times,
cover, 1986

Owen Wood,
Radio Times, cover,
Christmas, 1975

especially for music features. Two covers in watercolour were contributed for the 1982 (p.50) and 1985 *Proms* seasons. Although illustrating is a prime love, writing - the creative process is similar - also

Bill Sanderson, 'John Betjeman', Radio Times, mid-1970s

allowed him to write children's books and contribute humorous arts features to Radio 4, and to Radio 3's 'New Premises'. For a *Radio Times* illustration for this satirical series he drew a subversive ferret with an erection that strangely brought no complaints. A drawing for a programme about the origins of the Dracula myth, however, brought a threat of legal action from descendants of the Duke of Montefeltro when he 'adapted' Piero della Francesca's portrait by

inserting a trickle of blood from the Duke's mouth.

The illustrations of Ian Pollock (p.54, lower) transcend categorisation. The drawings, treated in a style that resembles drawn on the stone lithographic prints, are beyond cartoon or caricature, presenting a darkly humoured view of humanity that is nearer to those masochistic depictions of hell in medieval wall paintings in out-of-the-way Scandinavian churches, than any contemporary trend. In the 1980s, a poster he drew for the Royal Shakespeare Company's production of *King Lear* brought him a commission to illustrate a cartoon version of the play for a book, published by Oval Projects; he has also illustrated Milton's *Paradise Lost* for The Folio Society.

Ian Beck began working for *Radio Times* in about 1970. In the drawings that he produced, and the two covers he painted in the mid 1980s, his affection for the graphic work of the 1920s is demonstrated.

Working first as a teacher at a London comprehensive school, then as a graphic designer for London University, Ingram Pinn contributed drawings to *Radio Times* from 1978. These are an amalgam of traditional cross-hatching or line and wash drawing techniques, often with a surreal twist, though in this his models would be the savage drawings that highlight serious political debate in Eastern Europe.

The ubiquitous Peter Brookes began working for *Radio Times* in the early seventies. Brookes regrets having done little pure drawing whilst at art college where, he says, he was encouraged to think. His drawings, amongst the most popular published by *Radio Times*, were distinguished by his unique ability to illuminate complex ideas through simple graphic metaphors. These are always executed with craftsmanship, and knowledge of historical styles. Peter Brookes' talent for creative originality has subsequently achieved legendary status in *The Times* newspaper where his uniquely lateral imagination and ability to translate contemporary events into pithy pictorial commentary has undoubtedly become one of the *Old Thunderer's* greatest attractions in recent years.

As the technology for printing half-tone improved these artists of the line drawing were joined by those working in continuous tones, either in black and white or colour. Pauline Ellison recalls that she "began working for the *Radio Times* in 1969. David Driver, who had taught me at Cambridge Art College, became art editor in that year and he first commissioned my

Hannah Firmin, 'Medieval Feast', Radio Times, 1978

linocut, Clare learned her own technique as she went along, studying early English chapbook illustrations and the work of other traditional and primitive block printers. She uses 2.5mm flooring quality lino for her cuts and proofs them on a simple, small (300 x 230mm) cast iron screw press using linseed oil based relief printing ink by T. N. Lawrence & Son Ltd. The tools she uses are also made by the same firm - lino-cutting gouges and V-tools.

Bill Sanderson contributed his first illustration for *Radio Times* in about 1973. It was, he says, "rejected by David Driver, but he had the patience to try again and I started my longest professional relationship not long after."[37] On the advice of Charlie Riddell at *New Society*, Sanderson began using scraperboard, a medium that he has used almost solely throughout his career. He uses white boards, inking the area to be drawn with waterproof black ink and then works with No. 1 scraper cutters.

Sanderson's work, amongst the most proficient examples of the scraperboard technique, is still to be seen in the pages of *Radio Times*. His ability to replicate the quality of wood engraving - now introducing colour into his illustrations - always enhances the publications he contributes to.

The bravura line work of Edward Ardizzone and Robin Jacques enjoyed a renaissance in the work of Peter Brookes, Ingram Pinn, Ian Pollock and Peter Till. Pinn, Pollock and Till coincidentally achieving a style that drew on East European sources and those of

Glaser and Schwast at New York's *Push Pin Studio*.

The challenge of creating a full spectrum of tonality for *Radio Times* illustrations exercised artists throughout the magazine's existence. The limitations of letterpress print technology and of paper stock mitigated against the kind of tonal gradation that photogravure or offset lithography achieved. Photographs and illustrations reproduced as halftones often appeared darker than the originals as the blocks inked up.

Drawing upon eighteenth-century stipple engraving techniques Martin Baker produced illustrations where the tonality was created by individual mapping pen dots of ink. He was commissioned from the early 1970s until 1990 to make drawings for *Radio Times*,

Clare Melinsky, 'The Countryside in Autumn', Radio Times, 21st October 1983

Lynda Gray, 'The God of Glass', Radio Times, mid - 1970s

Hannah Firmin says, "My technique is a mixture of wood engraving and linocut, using vinyl blocks with oil based inks from T. N. Lawrence. I work from life or imagination, never from photographs! The drawing stage is very important to me, together with the design generally. This principle was set by being taught drawing by Susan Einzig and Roy Spencer at Chelsea, and Linda Kitson at the RCA, all who were specially important to me, as was Quentin Blake at the RCA. Susan Einzig often spoke of John Minton. She introduced me to Hugh Casson who was a great supporter of my work, and greatly encouraged me. *Radio Times* was always held in high regard and used as a good measure of what illustrators were doing. Robin Jacques, Peter Till, John Lawrence, Adrian George and Chloë Cheese were some

John Lawrence, 'Colonel Jack', by Daniel Defoe, The Folio Society, 1967

of the people whose work I looked out for. My father's [Peter Firmin] illustrations for his programmes such as *Ivor the Engine,* and *Noggin the No*g were often featured.

"Art directors were very important in the 1980s. They seemed to value design and drawing skills highly and were willing to use new and unusual illustration. When I take my portfolio to show art directors now they seem not really interested in looking. They flick through the portfolio and often express surprise that I have a wide variety of work in it! I have the distinct feeling that they only feel comfortable seeing images on a screen! As my work is very 'hands on', a primitive

Caroline Church, 'Network East', Radio Times, 9th March 1987

technique - the relief print - they find it hard to accept. So this has attributed to the decline in commissioned editorial work that I do, and I tend to exhibit my work on a more personal level now. I feel that 'craft' skills and drawing are undervalued."[36]

Clare Melinsky worked for *Radio Times* from 1978 until about 1987. She initially showed her lino cuts to *Radio Times* because they still used simple black-and-white graphic work. Jenny Fleet was then an assistant art editor, and asked for a series of illustrations for *The Countryside in Autumn,* then *Winter, Spring,* etc. She went on to commission an illustration about once a month on very varied subjects: plays, the countryside, and decorative headings. Working in the medium of

John Vernon Lord, The Cat and the Cock, Aesop 'Fables', Jonathan Cape, 1989

The ideals of the scraperboard work and wood engravings of Badmin, Bacon, Harris and Tunnicliffe were continued in the work of Caroline Church, Hannah Firmin, Clare Melinsky and Bill Sanderson. Hannah Firmin and Clare Melinsky work with vinyl and lino, whilst Caroline Church and Bill Sanderson use scraperboard. The results demonstrate these artists' proficiency and respect in replicating the appearance of wood cuts and engraving in work that Bewick would not be ashamed of having produced.

While not having worked for *Radio Times*, John Lawrence is included for his influence both as a wood engraver, producing outstanding work for commercial publishers, and also as a teacher of illustration. His work for The Folio Society, especially his *Colonel Jack* (1971), proved that, in the hands of great artistic talent such as his, dead wood can live again.

Caroline Church worked regularly for *Radio Times* from 1988 until 1991. Her skill with scraperboard was demonstrated in many commissions where her decorative skills and sensitivity to traditional wood engraving styles are apparent. She is another artist who fell foul of the perceptive eye of the *Radio Times'* reader. Having drawn some minute ships in the background for an illustration of a play set in the 1920s, a number of letters were sent to her pointing out that they were historically inaccurate.

Describing the technical process of her work,

Once, in the *'French'* pub in Soho, discussing the relative merits of drawing nibs with Robin Jacques, a friend of many years, Wood listened as Jacques extolled the virtues of the Gillott 303, while he argued for the finer qualities of the 290. Someone overhearing their conversation, reached the alarming conclusion that they were talking about guns.

One of the last of the truly exceptional illustrators represented by Saxon Artists was Janet Archer. She had travelled throughout Europe, the Middle East and Asia, and this experience greatly influenced her. The drawings that she contributed to *Radio Times* from the mid 1960s possess an exuberant freedom where the line achieves abstract expressionist qualities. Her decision to work exclusively in film animation - she contributed to Geoff Dunbar's *Lautrec* which won the *Palm D'Or* at Cannes in 1975-represented a great loss to illustration in

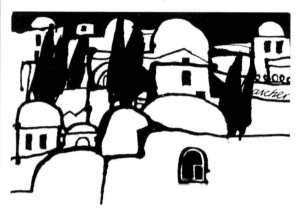

Janet Archer, 'Jerusalem', Radio Times, 1960s

Britain, although her recent work, which demonstrates an extraordinary graphic imagination, using the narrative skills acquired by her work in cinema, is a series of brilliant colour illustrations for a Japanese fable that cries out for publication as a book or making into a film.

Growing up in Glossop Derbyshire, where his father had a bakery and café, John Lord remembers L. S. Lowry regularly visiting for his high tea of plaice and chips, followed by apple pie and custard. On seeing work from Lord's final exhibition at Salford Art College he remarked to his father "John's got plenty of imagination, Mr Lord."[33] Their talk, however, was of music, especially of Bellini and the *bel canto* repertoire, rather than art. Following Salford, Lord applied for a post-graduate course at the Central School of Arts and Crafts where he studied with Stanley Badmin, Morris Kestelman, Laurence Scarfe and, occasionally, Mervyn

Peake, whom he remembers as being noticeably poorly at the time. Encouraged by Laurence Scarfe and John Burningham he left full-time study to free-lance as an illustrator and to teach. He joined the Saxon Artists agency in 1961 as an illustrator, and also Brighton College of Art as a part-time lecturer in illustration. His appearance there was quite electrifying. He showed students his illustrated diaries, drawings and text executed with a *Rapidograph* - a notoriously temperamental capillary drawing pen whose tubular nib clogged at every opportunity. These minutely detailed pages created an indelible impression upon the students. He first drew for *Radio Times* in 1963 and continued receiving commissions for the magazine until appointed a full time lecturer in Brighton in 1968. He continued illustrating, producing award-winning children's books, writing and illustrating *The Giant Jam Sandwich* for Jonathan Cape (1972). His distinguished career as an educator, becoming Professor of Illustration in 1986, was rewarded following his retirement in 1999 with an Honorary Doctorate of Letters from the University of Brighton in recognition of his "outstanding contributions to practice and to education in the illustration of books and printed texts".

Styles of an earlier generation, like the abstracts of Reinganum and Fraser, found their modern peers in artists such as Lynda Gray and Brian Grimwood. From 1971 Lynda Gray contributed images in an elegantly simple linear style. Like many illustrators of the time, her determination to become an illustrator was entirely due to the influence of *Radio Times*. She recalls that "I must have started noticing *Radio Times* illustrations when I was under ten years old, in the 1950s and soon started cutting them out and pasting them in my scrapbook. They were more interesting and idiosyn-cratic than the drawings in my comics; sometimes spooky, exciting, romantic, whimsical, heroic. Occasionally the scratch and splatter pen marks could only just be deciphered, but I devoured those tiny drawings, and knew that somehow, one day, that's what I wanted to do."[34]

She presents a bleak view of illustration at the present time. "Looking at the illustration scene from a distance, I no longer recognise it. There are art directors who can't tell good from bad, and illustrators who can push buttons, but can't assemble a colour scheme."[35]

David Driver, detail of drawing made at art college in Cambridge, 1959-60

pre-eminent style of the graphic and where narrative interpretation is largely absent.

British art students responded to this new international style and broke free of insular national constraints to produce work indistinguishable from their peers abroad. The kind of figurative realism of earlier illustrators is avoided, and ideas, often with a surreal twist, are invoked. One of Driver's most original ideas was to commission Frank Bellamy (1917-76), one of the artists who drew *Dan Dare* for *Eagle* comic, to produce illustrations for *Dr Who* features. Bellamy also contributed powerful black and white drawings with a narrative style that gave the subject clarity.

Ivan Lapper was commissioned to produce drawings to give the effect of photographic montage. The style cleverly imitated the style of cinema posters and required a great deal of research. Working free-hand, at up to A1 size, Lapper produced dramatic realisations of the features he was commissioned to draw. In 1972 he painted the first colour illustration for a *Radio Times* feature page, for the series *Colditz*. Sadly the finest drawings that he made have disappeared - many illustrators discovered that their work had been 'given' by *Radio Times* to actors, presenters and

producers, often without seeking permission from the artist, and certainly without payment. I was told that it was "what *Radio Times* does", when a well-known presenter asked for the original of a drawing that I had made of him and had impertinently questioned this practice.

David Driver was a superb stylist at *Radio Times*. Like Gorham and Usherwood before him he encouraged novel graphic techniques, introducing young artists straight from college. This, unfortunately, led to many of the older generation of illustrators losing regular commissions from the magazine. The agent R. P. Gossop, representing Fraser, Bacon and Reinganum, was told that the *'old timers'* would no longer be used, although artists like Eric Fraser and Robin Jacques continued to contribute work. Victor Reinganum gave up illustration altogether at this time; others, like Jim Russell, represented by Saxon Artists, felt philosophical about the new broom and that the magazine had changed from its traditional vehicle of presenting narrative illustration.

With television dominating the pages of *Radio Times*, photographic stills from the actual production were used in place of illustrations. Where drawings were included, at least for the television pages, they mostly presented an abstraction of the programme's subject. The radio pages became a repository for traditional styles of illustration.

Ivan Lapper, 'The Scandalous Death of Adolf Hitler', Radio Times, 1st May 1975

Owen Wood, who had taught David Driver at Cambridge, possesses an exceptional technique, a combination of delicate line and wash. Wood's *Radio Times* Christmas cover of 1975 (p.48) is a work of artistic and technical brilliance. There are three ellipses which he has drawn with an unlaboured spontaneity that today could only be approximated by computer.

the philosophy of content and subject coming first. Reading was essential. Peter Dunbar, art editor of *The Economist*, taught typography and the rudiments of magazine design thoroughly. Alec Heath, the head of College, was involved with industrial and exhibition design, and was very strict on æsthetics, colour and architectural appreciation. I was very lucky to have had such strength of influence and education from these people over the four years. It was down to them and hard work, that enabled me to progress as soon as I arrived in London."[31] His first illustration commission was for *Queen* magazine whose art editor, Tom Wolsey, had just moved from *Town*, where he had achieved great things. The piece was a double page spread, for a Nabokov story.

David Driver recalls "In 1968/9, I worked for Cornmarket Press with Geoffrey Cannon, Clive Irving, Clive Labovitch and Nigel Holmes. We were approached in secret by BBC Publications to look afresh at the whole construct of *Radio Times*. So a dummy was printed and became the blueprint for the eventual magazine. I decided on Franklin Gothic for headlines, Garamond Italic with swash letters for introductions while retaining the body text, Royal. I was impressed with the body text for its deep lowercase characters, that worked particularly well at small sizes. The newsprint was lowgrade and the presses ancient, it was a miracle getting our journalism to work, given these constraints. The masthead design came first. The plan was to rename the journal simply '*RT*', which I designed as two Garamond swash letters. The idea was that these would stand for '*Radio Times*', but also could mean 'Radio *and* Television'. We were going to try to wean the consumer away from the radio emphasis and to get the attention focused on the television element. Surprisingly, there were people then who didn't know that television was included in the journal, and others who rejected television totally. It was decided

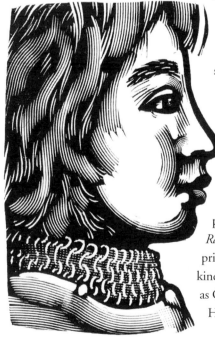

David Gentleman, 'The Maid of Orleans', Radio Times, 10th September 1970

to retain *Radio Times* in full, so very late in the proceedings I injected the required characters between the *R* and *T*. After a few years, I involved typographer Matthew Carter to re-draw a longer, flatter masthead, retaining the swash essence and that lasted a very long time."[32]

Cannon and Driver inherited a magazine that, for a substantial period of the previous decade had looked

David Driver ©The Times/Hubbard 1999

like its ITV rival. The new art editor utilised the full armoury of graphic techniques to produce an outstanding design solution that appeared from the first week of September 1969. These issues look fresh and undated even today. The covers used full colour photographs, cropped for dramatic impact and, taking advantage of the typographic subtleties of the recently introduced photocomposition for text, headlines were letter spaced closely to create a powerful visual dynamic. Cannon eschewed verbosity in these and Driver was able to contribute eye-catching designs that rivalled Milton Glaser's for *New York Magazine* or Hillman's for *The Sunday Times magazine*. A truly sophisticated touch was the use of swash italics for sub-head captions on the feature pages. Unfortunately circulation dropped by about a quarter of a million.

The influence of Glaser and his associate Seymour Schwast of the New York *Push Pin Studio* is also present in the choice of illustration for *Radio Times*. In the 1960s, with colour printing becoming economical, a new kind of illustration appeared. Artists such as Glaser and Schwast in the USA and Heinz Edelmann, working for *Twen* in Germany, created a new graphic syntax where colour and pop derived abstracted designs were the

gradual transition from monochrome to full colour covers which began to appear from the spring of 1967.

Although the sixties have been described as 'swinging', it would be more accurate to describe the decade as a continuation of Auden's 'Age of Anxiety', the fifties. The nuclear threat was an ever present concern throughout the earlier decade, however, during the three days, from 17th to 20th April 1961, Kennedy's thwarted invasion of the *Bay of Pigs* in Cuba made the possibility of annihilation an almost imminent reality. The four-minute duration of life expectancy engendered a kind of Epicurean existentialism. Elected authority seemed impotent and a sense of futility at the incompetence of their elders gave licence to youth to motivate political change and to elevate their generation as the creators and arbiters of culture.

In publishing, Jocelyn Stevens and Mark Boxer's *Queen* had enormous impact for this young and affluent generation. Other new magazines, like *Town,* emerged in the UK to capture this new youthful and cynical market; *Private Eye* was launched in October 1961; *Nova* appeared, designed by David Hillman, who then went on to design *The Sunday Times magazine* in 1962, and in Germany, *Twen* (German slang for teenager), a large-sized monthly that greatly influenced Hillman's *Nova,* was founded and designed by one of the most innovative art directors of the time, Willy Fleckhaus. *Radio Caroline* began broadcasting in 1964 and London telephone exchanges became entirely numeric, losing the poetry of prefixes like, '*BAYswater*', '*GROsvenor*', and '*DOMinion*'.

BBC television introduced *That Was The Week That Was* in 1962, and commissioned features from the various members of the *Cambridge Footlight Reviews -* Jonathan Miller, Alan Bennett, Dudley Moore and Peter Cooke. In Ken Russell's *cinema verité Monitor* film, *Pop goes the Easel* of 1962, Peter Blake, Derek Boshier, Peter Phillips and Pauline Boty presented an exuberant platform for Pop Art.

Changes to *Radio Times* were made in an attempt at attracting this younger generation. In September 1967 the magazine appeared with youth-oriented appeal, the cover focusing upon the newly introduced *Radio 1*. Douglas Græme Williams retired through ill health early in 1968 and C. J. Campbell Nairne, then close to retirement as the deputy and literary editor, was promoted in the interim as editor.

At the age of twenty-nine, in 1969, Geoffrey Cannon was appointed editor, the youngest person to hold the position. He had won a scholarship to Balliol College, Oxford. On graduating he joined *New Society*, before moving to IPC. Cannon's arrival at *Radio Times* must have seemed threatening to long-serving members of the staff, however, he clearly had immense respect for their experience, "It was as if they belonged to another race. I'd never met people like this before. I'd been warned that I'd find the civil servants very stuffy but I found them completely honourable. I've found a particular warmth for the older people… these are people who've been dedicated thirty years to an ideal".[30]

From September 1968 ITV's *TV Times* was printed in full colour and, content apart, looked superior to *Radio Times,* which could only offer colour on selected pages and on the cover. Cannon decided to drop non-programme related material, such as cookery, gardening, and travel, and to reconstruct the magazine, concentrating on its function as a listings magazine. He recruited David Driver, with whom he had worked at IPC, as art editor.

A Co-ordinated Design Aesthetic

One of Cannon's most innovative ideas was to reduce '*Radio Times*' to the initials '*RT*', becoming an acronym for '*Radio and Television*'; he was allowed to change the masthead to an italic Garamond font with enlarged swash initial caps, however further abbreviation was forbidden leading to the *reductio ad absurdum* of a magazine dominated by television called *Radio Times*.

David Driver was educated at the Perse School, Cambridge and then at Cambridge College of Art (1959-63). On graduating he free-lanced as an illustrator, represented by the Saxon Artists Agency. However, he decided to forego the loneliness of the long-distance illustrator for the more congenial atmosphere of corporate life. In 1963 he joined the Thomson organisation before moving to IPC where he became assistant art editor of *Woman's Mirror*, and then moved to *Harpers Bazaar* as art editor.

Of those that influenced him at art school he remembers, "…the teachers, rather than trying to ape other publications, Owen Wood, John Norris Wood and Paul Hogarth were instrumental in insisting on

colour was introduced regularly for the cover. The magazine, however, remained essentially unchanged. The BBC, like the nation itself, seemed impervious to the portents of change in the world. The invasion of Suez by the British and French in 1956 was a last humiliating convulsion of potency for these two colonial powers. In Budapest students rose, unsuccessfully, against their Soviet occupiers. Ingmar Bergman filmed *The Seventh Seal* and three years later Françoise Truffaut made *Les Quatres Cents Coups*, two films which consolidated the all too brief period of truly great cinema.

For graphic artists, other cinematic influences included the superlative credit sequences that Saul Bass (1920-96) designed for the films of Hitchcock, and also for Preminger's *St. Joan* and *Exodus* and for Kubrick's *Spartacus*. Youth embraced the hedonism of 'Beat'. Fortunately the British had Spike Milligan who triumphantly created a new role for the nation as *The Goon Show*.

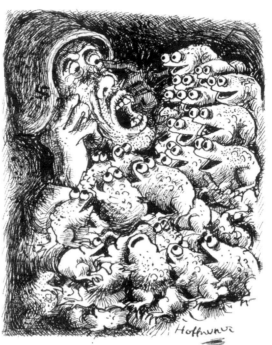

Gerard Hoffnung, 'The Farm of a Thousand Frogs', Radio Times, 19th September 1947

Keeping Up Appearances

Radio Times has essentially retained the same formatting, based on a four column grid, throughout its existence. The changes in design that have taken place have all concerned pagination, changes in typefaces and, as printing technology improved, the transition from monochrome to full colour. In 1970 a five column grid was introduced for the radio pages. By 1979 paper costs demanded a more economic use of space and six columns of text were used.

Significantly the *Radio Times* masthead, variants of a Rockwell slab serif in capital letters, remained substantially unaltered from the late 1930s until October 1960 when Abram Games (a surprising choice, suggested designer and illustrator George Mackie recently, given that Games was not specifically

noted as a typographer) was commissioned to design a modern version. His solution was a rather brutal, hand drawn, condensed sans serif upper and lower case that reflected contemporary typographic trends. It was, however, unsatisfactory and less than two years later the masthead was revised, returning to a more reader friendly serif entirely consonant with the style of the 1960s. Of more lasting consequence, Games redesigned the inside page layout, creating a more legible typographic solution, with Doric as the typeface used for headings and Royal for the body text.

Radio Times, unlike any journal of its type, is noted for the scrupulous attention given to language and style; rarely, if ever, are accents: grave, acute and umlaut, ignored, especially in the setting of French and German; although some of the more esoteric inflexions - especially those of eastern Europe - are ignored; however, even where Cyrillic text has to be transliterated, there is a consistency that is remarkable. In 1996 *Radio Times* published an in-house style guide that is a model of English, its usage and abusage.

Ralph Usherwood, after ten years as art editor of *Radio Times*, relinquished the post to Peter Harle in 1959, the first time that the position had been occupied by an art editor with formal art school training. Harle had studied at the Central School of Art and had been Head of the Labour Party's art department. He was to maintain the celebrated roster of *Radio Times* illustrators throughout his editorship which lasted until 1968.

In 1964 the BBC introduced a second television channel, *BBC2,* which finally flickered onto the nation's screens on 21st April 1964 - a massive electricity cut in the West London area had delayed the scheduled previous evening's launch.

Perhaps the greatest change that Peter Harle had to accomplish during his tenure at *Radio Times* was the

about 1955 it was suggested to Geoffrey Strode, the General Manager of BBC Publications, that the Corporation should register the name *'TV Times'*. Strode refused, replying that he didn't think that television would catch on. By 1957, however, the pages of television listings preceded those for radio. Eight different editions had to be produced for each of the regions. Consideration was also made for cultural sensibilities in Wales, Scotland and Northern Ireland. A separate Welsh edition allowed a cover for the Eisteddfod, with the text almost entirely in Welsh; at New Year, a Scottish edition featured Hogmanay; and special covers were also published in Scotland and Northern Ireland when specifically English events were featured.

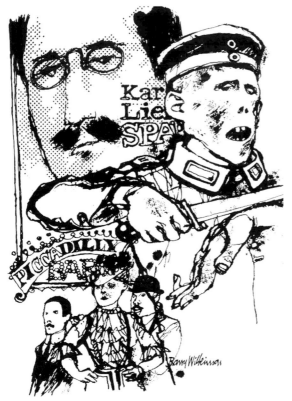

Barry Wilkinson, 'Drums in the Night', Radio Times, 12th September 1968

Industrial unrest caused disruption to the printing schedules. In 1950 the internecine conflicts between the various print unions, which continued intermittently throughout the next three decades, began with a dispute between the London Master Printers and the London Society of Compositors.

Tom Henn died in 1954 and Douglas Græme Williams, who had joined *Radio Times* in the 1920s, was appointed Editor. His years of experience as art editor must have been a positive influence on

Usherwood who expanded the repertoire of artists.

Formatting the material for the next week's issue took until Thursday, though this was often delayed to the Friday, when illustrators would be chosen and briefed. Usherwood described the routine: "There was thus just a week in which to get everything ready for the printer. By the first day the layout of the programme pages had been drawn up and space allocated for illustration. This was when the artist was commissioned. He had three days - and four nights in which to complete his work. The process engraver was left a day and a night in which to make the blocks.

"All the artists were employed on a free-lance basis to do the work for which they were thought best fitted. Scripts of plays, features and information about programmes were made available for the art editor to read, and the content of the text suggested a particular artist to him. The size of illustration was determined by page layout. When the artist was commissioned he was told the exact proportions to which he must draw and given the deadline for delivery. There was no time for roughs or alterations; a drawing was either good enough or - very rarely - unusable. It was essential that the original drawing, whatever its size, should scale to the correct dimensions, for the typographical layout to contain it had gone ahead of it to the printer. Block and type came together on press day - and by that time galleys were available for another week."[29]

In 1955 Independent Television began broadcasting in the London area and *TV Times* was launched. Both BBC and ITV publications retained complete copyright of programme listings of their respective programmes. *TV Times* appeared as a brash upstart alongside the imperious *Radio Times*, each magazine studiously ignoring the existence of the other. Insidiously, however, the influence of its competitor was felt at *Radio Times* with a gradual change to a style, in cover designs at least, that reflected popular tastes. Inside pages, specifically those for radio, retained the tradition for fine illustration and Ralph Usherwood fought to consolidate *Radio Times'* reputation of fine art patronage by refusing to lower the standard of the commissioned drawn work. Even when a cover demanded the inclusion of a photograph of a television personality, for example, this was somehow incorporated into a hand-drawn graphic background.

The competition by the independent listing magazines caused ripples at *Radio Times*. A second

Terence Greer, Radio Times, title and date unknown. Private collection

grant, initially at Saint Martin's School of Art, then
Twickenham School of Art before being accepted by
the Royal College of Art. On leaving college he showed
his work to Cara Strong at Saxon Artists and was taken
on by the agency. The style that Greer developed owed
something to that of monoprints; he developed a
technique where the drawing was created in pencil,
then inked in and transferred to blotting paper. The
resulting reversed image possesses an arbitrary
spontaneity that created a great impression when
reproduced. In the 1970s Greer changed direction
from illustration to writing; *Psychrons,* a story for a *Dr
Who* series (1981-84), is credited to him, however, his
subsequent career has been impossible to trace.

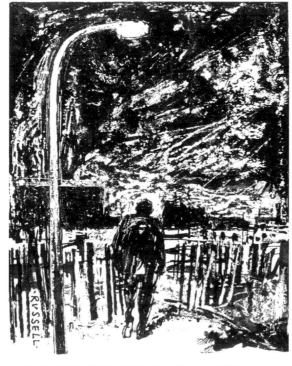

Jim Russell, 'My Friend Charles', Radio Times, 8th August 1963

The illustrations that Jim Russell contributed to
Radio Times were dramatic, due in no small part to his
willingness to allow for almost tachist abstraction in his
drawings. He had initially studied art at Birmingham
College of Art. After National Service, which he spent
in Singapore, he returned to art college to qualify as an
art teacher and taught for a year before leaving to
become a free-lance artist, he also taught illustration
for many years at Saint Martin's School of Art.

Other subjects required different specialties. Barry
Wilkinson had great skill in capturing movement in
his drawings and contributed many illustrations for
sports features. He studied at Dewsbury School of Art
then served with the RAF during World War II. On
demob he spent two years studying graphic design at
the Royal College of Art. After a variety of jobs,
including animated film design and teaching at
Wimbledon School of Art, he became a free-lance
artist. His outstanding work for *Radio Times* is
complimented by his skill as a graphic designer.

The 1950s, Action and Reaction

On becoming art editor, Ralph Usherwood wrought
subtle changes to the formatting of *Radio Times*. He
managed, drawing from his wealth of typographic
experience, to achieve a greater coalescence between
type, paper stock and illustration. Usherwood practised
the adage that 'one picture is worth a thousand words',
often allowing illustrations to appear without caption.
Whereas Maurice Gorham successfully practised the
zeal of the dilettante, Usherwood brought the skills of
a true graphics professional to the role. His authority
and his cultural sympathies accorded entirely with
those of the Corporation at that time. For the
illustrators he commissioned this meant that there
could be no cutting of corners - however small the
printed version of an illustration was to appear, the
details had to be accurate. Examples of original artwork
of the time are covered with minute corrections, which
would have been almost impossible to see when
reproduced.

The regional nature of BBC transmissions in
addition to formatting the three radio programmes,
made the editing of *Radio Times* a complicated
business. Accommodating television listings was not
made any easier by the ambivalence that the
Corporation felt about their new television service. In

illustrators was Lynton Lamb. He was born in India in 1907 but grew up in England. On the death of his father he was forced to leave school and work in an estate agent's office. In the evenings he attended life drawing classes under Randolf Schwabe at Camberwell School of Art. From 1928 until 1930, he studied at the Central School of Art, under Noel Rooke, Bernard Meninsky, and A. S. Hartrick. Lamb joined Oxford University Press in 1930 as a production adviser, working on the design of bindings for its prayer books and bibles - in 1953 he designed the binding for the

Lynton Lamb, 'Tartuffe', Radio Times, 9th August 1951

Coronation Bible. While sharing a studio with Victor Pasmore he became influenced by the work of the Euston Road School.

Lamb believed that literature did not need illustrations to explain it; however that if drawings were to accompany the text then they should be well drawn, from life and accurate. In addition to illustrating books and magazines he designed stamps and the Purcell Memorial for the Royal Festival Hall; he also taught at the Slade School of Art, the Royal College of Art, and the Ruskin School of Art in Oxford.

Lynton Lamb and Edward Ardizzone were possibly the archetypal *Radio Times* illustrators of the 1950s. In

many ways they worked from opposite ends of creative originality, Ardizzone drawing from memory and maintaining that illustrators were 'born', while Lamb insisted on drawing from life, using as much research as possible. Stylistically their work differs in that Ardizzone's drawings have the appearance of etchings while Lamb made drawings that resemble lithographic prints; and, whereas Ardizzone's work has the vivacity of a Rowlandson sketch, Lamb's earnest, lugubrious approach reveals a more cerebral personality. Lamb also used a variety of mediums, wood engraving, chalked lithographic stones and zinc plates.

The Saxon Artists Agency

Artists are, for the most part, reticent when it comes to negotiating terms for their work. The creation of the actual art work is a small proportion of the time involved in the whole commission. Initially there is the considerable time involved in showing one's portfolio of work to potential commissioning art editors. This used to involve trudging to various publishers throughout London carrying a heavy folder. Today the low cost and reasonable quality of colour laser printing, together with the unwillingness of today's art editors to give time for interviews, has made this exhausting marathon unnecessary. The interpretation of the brief follows, with research, the supply of ideas and rough sketches, before, finally, the enjoyable process of drawing.

Negotiating fees, too, is often a *bête noire*. Many artists insulate themselves from this by choosing an agent to represent themselves. Although the artist will lose about 25% of the commission's fee, the agent will usually compensate for this by achieving better terms, and more work. In respect of the minimal fees paid by *Radio Times*, artists were prepared to accept such low payments because the magazine was used by other art editors as a resource for choosing the best in black and white illustration. It was certainly true that an illustration that appeared in *Radio Times* was one of the best advertisements of one's skills.

By 1950 Cara Strong had established Saxon Artists in Oxford Street, London. She was soon joined by Barbara Thompson and Bill Farncombe, their business manager, and together they formed one of the most respected artists agents of the time. Cara Strong, she was always called '*Miss* Strong', was a formidable spirit

by *Radio Times*, Val Biro refined the ornamentation of the *cartouche* to perfection. Like Reinganum, Biro also possessed exceptional typographic skills and he was frequently asked to incorporate lettering into his drawings. This he did with great ingenuity and skill, by hand but also using Letraset, the newly introduced transfer method.

The materials he worked with included, ESSDEE white scraperboard, W&N Indian Ink applied by brush, and also by pen, using Gillott 290 nibs and Mitchell scraper cutters (mostly No. 2). He drew mostly from imagination, though reference pictures were employed for costumes, etc. As a boy in Budapest, Biro held a season ticket for the opera and saw virtually

Val Biro, 'Captain Horatio Hornblower', Radio Times, various dates from 1953

the whole operatic repertoire. He became the obvious choice when it came to commissioning illustrations for features of operatic and other musical broadcasts, many of them of obscure works from the repertoire.

European influences are also present in the work of Anthony Gross. He was born in Dulwich to a Hungarian father and an Italian/Irish mother. At the age of seventeen he went to the Slade School of Fine Art but stayed for only two terms. He couldn't afford to live in England and went to France in 1926 where living was much cheaper. For a short time he became a student in Paris at the Académie Julian, and at the Ecole des Beaux Arts. He then moved to Madrid. Working in France as a painter, film animator and producing etchings he developed an individual and free graphic style. In 1936 he illustrated Jean Cocteau's *Les Enfant Terribles,* intriguingly mimicking the author's own poetically simple linear style.

At the outbreak of the war he returned to London, where Kenneth Clark, having seen Gross' cartoons in an exhibition, asked him to become an official war artist. He joined a troopship to make a record of life on board and spent the rest of the war in the Far East.

On being demobbed Gross was commissioned by Heinemann to illustrate *The Forsyte Saga,* for which he received £500. These illustrations impressed Ralph Usherwood, who invited him to illustrate for *Radio Times* in 1951. His first commission was for Jean Anouilh's *Point of Departure.* This drawing, now in the Victoria and Albert Museum, is cited by Usherwood as one of the most distinguished ever done for the magazine. It imbues the subject with a dreamlike spontaneity and has the character of an etching, the Cocteau style is present and the radial lines invoke something of the Swiss painter Hans Erni who coincidentally had also studied at the Académie Julien.

For about five years, from 1946, Anthony Gross taught at the Central School of Art where Harold Cohen remembers him as a strict tutor "He would plumb line your drawing and if it was out of true you would be ordered in no uncertain terms to start all over again."[23] Peter Harle, another of his Central School of Art students, who became art editor of *Radio Times* (1960-68), asked Gross about his use of a plumb line. Gross' answer, in the light of his apparent loose style of drawing, that preliminary drawings required a vertical reference against which other lines can be measured, reveals something of his disciplined methodology.

One of the twentieth-century's most popular

Anthony Gross, 'Point of Departure', Radio Times, 2nd February 1951. Courtesy Victoria and Albert Museum

produced two books of drawings, *Radio Times* commissioned illustrations for *Romeo and Juliet* in 1954 (though in the depiction of the confrontation between Tybalt and Mercutio the streets of Verona have somehow acquired a Florentine patina). Other Shakespearean subjects followed, *A Midsummer Night's*

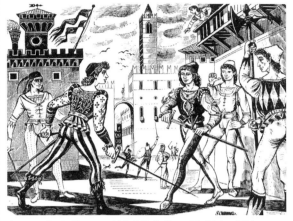

Laurence Scarfe, 'Romeo and Juliet', Radio Times, 8th October 1954

Dream, Love's Labour Lost and *Troilus and Cressida* in 1964. Primarily trained as a muralist, Laurence Scarfe accomplished the change to the smaller canvas of *Radio Times'* illustration sizes with ease, and Bawden's woodcut facility is present. He also succumbed to the temptation for humour to which some illustrators are prey, by once including a television ærial in the background of a drawing for *Dido, Queen of Carthage*. For this lapse he didn't receive another *Radio Times* commission for a year.

The craft of wood engraving and wood cuts is the oldest technique for reproducing printed images and text. Its origins, over one and a half thousand years ago in China, impose a burden of tradition upon all who practice the craft. The expense of box, the close grained wood customarily used for engravings, made it too costly a material to use for *Radio Times* commissions - scraperboard and latterly vinyl are used as an economical alternative. A rare exception was the work commissioned from Derrick Harris. Simon Brett, in his book on Harris, writes, "Derrick Harris loved working for *Radio Times*. He was given complete freedom in his commissions and always liked to visit the office to deliver the work himself. Surviving cuttings alone indicate that he completed at least a hundred regular jobs for the magazine - about 25 engravings and about 75 drawings - as well as the artwork for five pullout quarterly supplements on the

Third Programme and full-page covers for *The Listener*…he was known as '*Radio Times Harris*.'"[20] Writing in the year after Harris' suicide at the age of forty in 1960, Ralph Usherwood said, "No artist is quite original, but Harris was a wood-engraver with a particular and invaluable gift. His work had something of the gusto of the early nineteenth century."[21]

Derrick Harris claimed that he was born out of his time. "I should have been born in the time of Fielding," he said.[22] His work, influenced by Bewick and Ravilious, has a crisp vivacious charm that made Harris a sought-after illustrator for publishers such as The Folio Society for their editions of *Joseph Andrews, Tom Jones* and *Humphry Clinker*.

The work of Val Biro also draws from engraving sources using the medium of scraperboard. Biro was born in Budapest, and, at the age of eighteen, in 1939, he was sent by his father to train as an illustrator at the Central School of Art in London. On leaving college - the Central had removed to Northampton for the duration of the war - Biro returned to London where, barred from serving in the forces by his 'enemy alien' status, he served as an auxiliary fireman from 1942 until 1945. He worked for a variety of publishers before Ralph Usherwood commissioned his first illustration for *Radio Times*, a little decorative angel, in 1950. Influenced by Rex Whistler, he developed a style where baroque and rococo originals were given revivified potency. Of all the illustrators commissioned

Derrick Harris, 'Love in a Village', Radio Times, 16th November 1956

"… remarkably thorough, reading programme scripts and plays in full before deciding whom to commission. Finished work was then presented to a committee, which occasionally objected to drawings such as one by Leonard Rosoman [of a woman in a state of undress], illustrating Somerset Maugham's *Cakes and Ale* being included in 'a family magazine'."

The *Festival of Britain* from May until September 1951 and the Coronation two years later were catalysts that gave positive energy to the creative arts. The Coronation (televised in black and white and viewed on coarse 405 line, mostly 9 inch screen, television sets from 10.25 in the morning until 5.20 that wet June day) boosted national pride - and the sale of television receivers. Children of the time were solemnly told that

Radio Times editorial staff in 1950: D. E. Richardson, Ralph Usherwood and secretary. ©BBC

they were the 'New Elizabethans'. This momentum was created by the Labour Government, during the years 1945-51, whose monument was the creation of the National Health Service; though perhaps its greatest achievement was intangible: the sense of hope it engendered amongst a demoralised nation. For the first time in twenty-seven years *Radio Times* raised its cover price by one penny to threepence.

While television as a medium had received a much needed boost, it was radio that provided truly stimulating entertainment: two programmes which subversively encouraged the way ahead in the early 1950s were *The Goon Show* and *Home at Eight*, the latter, now sadly forgotten, presented Hermione

Gingold and Alfred Marks in a genteel version of Spike Milligan's surreal humour. Radio Drama had its own 'golden age' with Douglas Cleverdon's classic production of Dylan Thomas' *Under Milk Wood*; and broadcasts of great European theatre. The tradition is still maintained: in 1997 *Radio 4's* broadcast of Lee Hall's *Spoonface Steinberg* reaffirmed the power of radio drama with poignancy and immense impact.

One of the greatest caricaturists of the century, Ronald Searle contributed to *Radio Times* in the immediate post-war years. His drawings have a profound authority that avoids cartoon gestures. He also possesses a technique that is as effortlessly attractive as fine handwriting. At the outbreak of war Searle enlisted in the Royal Engineers where he spent part of the time at Kirkudbright. There he encountered evacuees from St Trinnean's, a progressive girl's school in Edinburgh. This resulted in his first cartoon for *Lilliput*, published in 1941 - later developed into his most famous creation, in books, and films. He was sent to the Far East where he was captured by the Japanese at the fall of Singapore and spent the remainder of the conflict as a prisoner-of-war, at times forced to build the Burma railway. Throughout this period, at considerable risk to his life, he made drawings of life in these camps, amongst them the infamous one at Changi. *The Enigma of the Japanese*, drawn just two years after his return to Britain is a powerful indictment. Searle's subtle indication of the sun falling from the sky is surely a metaphor for that nation's fall from grace.

Laurence Scarfe described his first effort for *Radio Times* as 'tin like' and was unhappy at the result. He persevered, however, and after travels in Italy, which

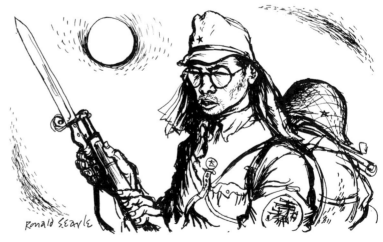

Ronald Searle, 'The Enigma of the Japanese', Radio Times, 8th August 1947

Jacques who had been invalided out of the army after serving in France, Holland and Germany. Remarkably Jacques was self-taught. Jack Coupland, who served at Plymouth with him remembers the artist often drawing in spare moments, creating doodles and that surprisingly "...the result was usually abstract."[18] Jacques began illustrating for *Radio Times* in 1945 and continued to do so until shortly before his death in 1995.

Throughout a truly distinguished career the quality of his black and white draughtsmanship never varied, except to improve, and his ability to indicate the texture and solidity of the things he drew was unparalleled.

There is a timeless quality about Robin Jacques' work that while overtly baroque is never pastiche. It transcends categorisation as mere narrative illustration for it

Robin Jacques, 'The Duenna', Radio Times, 17th December 1964

possesses a painterly quality where every nuance of tonality is respresented by delicate lines of great precision. Working often at the same size as the printed version he ensured that, however fine the original drawing was, it would retain every mark of his original when printed. In this he was able to draw on his own experience of print reproduction as art editor of the *Strand Magazine* between 1948-51 and his work for the Central Office of Information. His work elevated the many celebrated editions of The Folio Society's classics.

The Scholar as Art Editor

In 1950 Ralph Usherwood (1911-2000) joined *Radio Times*, by then situated at 35a Marylebone High Street, 19 as art editor. Usherwood was born at West Wickham in Kent and educated at St Dunstan's College in London, where his father was Headmaster. Usherwood showed early promise in drawing; he won an exhibition to Worcester College, Oxford where he

read Greats and surreptitiously drew caricatures for *Isis*. After Oxford Usherwood was recruited by the Closier Press, a firm of fine printers in Manchester. He became fascinated by printing history and typography and, in 1936, the firm sent him to Germany to study the new design principles and typefaces that were then beginning to replace the traditional *Frakturschrift* black letter. He also courageously drew cartoons of Hitler's Blackshirts. At the outbreak of war Usherwood was commissioned into the RAF where, at the age of thirty, older than the service usually considered for applicants, he trained in Canada as a pilot of flying boats. He flew a *Catalina* to Ceylon for operations against the Japanese. After the war he joined Odhams Press before moving to *Radio Times*.

'Ush', as Ralph Usherwood was always known, possessed the ability that all *Radio Times* art editors seem to have shared, that of managing to produce a weekly magazine to the highest standards on a shoe-string budget. He read the scripts of features and plays before giving illustrators the clearest brief of what to illustrate. His influence and enthusiasm for illustration encouraged the artists who drew for the magazine to extend their abilities, often by shepherding them into new directions by commissioning illustrations of subjects outside their immediate experience.

Usherwood was also a highly cultured man, widely read and with an intuitive skill when it came to matching illustrators' styles to the features published in *Radio Times*. Val Biro remembers sharing Usherwood's classicist sensibilities and it is clear that the art editor also had a thorough understanding of literary and musical history. His influence maintained the tradition of what is now considered a golden age of British illustration.

Ralph Usherwood's obituary in *The Times* of 2nd November, 2000, mentions that he was

John Minton, 'The Lady from the Sea', Radio Times, 19th September 1952

member of the *Neo Romantic* group of artists and writers, which included John Craxton, Susan Einzig, Rodrigo Moynihan, Dylan Thomas and Keith Vaughan, who met regularly at the studio of Robert Colquhoun and Robert MacBryde in Campden Hill, London. Their inspiration was cinema, especially the films of *auteur* directors such as Marcel Carne that they saw weekly at the *Academy* cinema in Oxford Street.

With Ayrton he designed the sets and costumes for John Gielgud's production of *Macbeth* in 1941. Minton also shared a studio with the *'two Roberts'* Colquhoun and MacBryde at 77 Bedford Gardens, London. Also in the same building were Ronald Searle and John Wyndham the writer. A committed socialist, at the outbreak of war Minton registered as a conscientious objector but he later joined the Pioneer Corps.

Minton produced a prodigious output of paintings, illustrations and drawings. His success as an illustrator was founded upon his knowledge of the variety of methods of print reproduction, and of typography and design. His illustrations really do resonate with the intensity of Palmer whose swirling moons he delighted in referencing in his work. Harold Cohen remembers Laurence Scarfe passing Minton on the stairs of the Central School of Art and asking, "How many half-moons have you drawn this week, John?"[16]

Minton's suicide in 1957 was a tragedy. Perhaps artists, who readily destroy work that they consider inferior, find it easy to destroy themselves when life also proves impossible.

His friend Michæl Ayrton was born in London. His father was the writer Gerald Gould, his mother the Labour politician Barbara Ayrton, and he adopted his mother's name in order to gain alphabetical prominence when it came to mixed exhibitions. Although his education was curtailed by illness, from 1935 he studied art at Heatherleys and St John's Wood School and then in Paris, where he shared a studio with Minton, while both studied under Eugene Berman. Ayrton also worked in the studio of the surrealist Georgio de Chirico. In 1937, aged sixteen, he spent part of the year in Vienna, visiting the *Albertina* and private art collections. Later Ayrton travelled to Spain in an attempt at joining the Republican Army. This was extremely embarrassing for his mother who at that time was a prominent member of the Labour Party with pacifist sympathies; however the Republicans wisely rejected him as he was under age.

Ayrton was a polymath, equally at home designing sets for the theatre, writing art criticism, painting and illustrating, broadcasting - he was a regular panellist in *Round Britain Quiz* - and in later years sculpting. Ayrton drew for *Radio Times* in the late forties. His work is free and spontaneous, although there is an inconstancy about his style that reflects at times vorticist (he was a friend of Wyndham Lewis, with whom he also worked when Lewis' eyesight began to fail) and at other times surreal influences. His later fascination for the myths of ancient Greece echoes the

Michæl Ayrton, 'Peter Grimes', Radio Times, 13th July 1945

neo-classicism of the time, as in Picasso's post-war preoccupation with nymphs and fauns, Stravinsky's reworking of Pergolesi in music,[17] and Graves in literature.

Radio Times began commissioning work from many of the servicemen returning from the war. One of the finest, who contributed for over fifty years, was Robin

page each to the *Light* and *Home* programmes and allowed for a greater number of illustrations in the magazine than had been possible for many years. Although print materials, ink and paper, were still in short supply, the magazine quickly recaptured something of the vivacity of its pre-war appearance.

A television service resumed for the London area in July 1946 necessitating supplementary television pages for the London editions - it wasn't until the mid-fifties, almost ten years later, that television broadcasts were available throughout most of the U.K. The inaugural evening's presentation started with a solo danced by Margot Fonteyn, continued with a repeat of the Mickey Mouse cartoon that had been the final transmission before the television service closed down for the duration of the war, and then went uphill to the final feature *'Koringa. The sensational circus performer with her crocodiles'.*

The promised *Third Programme* began on 29th September 1946. This avowedly intellectual channel was announced in *Radio Times* by Sir William Haley, Director-General, as being "…directed to an audience that is not of one class but that is perceptive and intelligent." The first evening's broadcast, self-deprecatingly began with Stephen Potter's satirical, *How to Listen*, with an example by Joyce Grenfell of *Third Class Listening*. It continued with Bach's *Goldberg Variations* played by Lucille Wallace, followed by a concert of English music conducted by Sir Adrian Boult, with the BBC-commissioned *Festival Overture* by Benjamin Britten (a courageous choice given Britten's stand as a conscientious objector during the war). At 10.40 pm Nadia Boulanger's incomparable 1937 recording of Monteverdi *Madrigals* was played.

In the chaos of reconstruction after the war the insular social and cultural walls of a besieged nation began to disintegrate and artists responded to the new freedom by absorbing new influences. Returning servicemen and women took advantage of the newly elected Labour Government's educational grants to enrol in courses of further education. In the capital the London County Council supported these initiatives with radical zeal. The art colleges, Camberwell, Sir John Cass, LCC Central School of Art (later Central Saint Martin's College of Art and Design), London College of Printing, Goldsmiths', The Slade, and the Royal College of Art, provided exemplary tuition, employing teachers who included

the finest practising artists of the time, including S. R. Badmin, William Coldstream, Susan Einzig, Bernard Meninsky, John Minton, Rodrigo Moynihan, John Nash, Mervyn Peake, Leonard Rosoman, Ruskin Spear and Keith Vaughan.

One illustrator almost defines the age. John Minton produced outstanding work for *Radio Times*. This is distinguished by a powerful graphic rhetoric that defies the limited size of the published drawings. These have a ferocious, brooding, dynamic that is as uncompromisingly romantic as the dark mystic landscapes of Samuel Palmer.

Minton's influence in his work and his teaching at Camberwell School of Art (1943-7), the Central School of Arts and Crafts (1947-8), and the Royal College of Art (1948-56) was enormous. Margaret Levetus has a vivid memory of this charismatic artist, "I think it was in the late 1930s that I became aware of his existence, when I took a picture to be framed by Mr Colley, who had a shop in Belsize Park. I noticed a painting - a portrait of a young man in various tones of blue - and found it attractive, although rather sombre. I asked Mr Colley who had painted it, and he said it was a young man called John Minton.

"The only time I met John Minton was in 1950 (I think) when Susan Einzig and I were both teaching at Sir John Cass College in the City of London. I taught wood engraving, lithography and life drawing. Susan arranged for John Minton to come and give a talk to all our students. It was a great success. With simply a blackboard and a piece of chalk for visual aids, he talked about drawing, occasionally demonstrating with a few lines, and kept his audience enthralled. He shimmered with vitality and looked like an extremely animated El Greco character - dark, thin and elongated, but full of fun. He must have been a most inspiring teacher, and he was a superb illustrator."[14]

Veronica Hitchcock, who worked as a temp for *Radio Times* in 1952 (she later joined the magazine full-time in 1967, becoming features editor), remembers "Johnny Minton sweeping into the offices wearing a long black coat with an astrakhan collar looking very Russian to deliver his drawings for the week."[15]

John Minton, related to the family of the ceramics firm, also painted. He had studied art at the St John's Wood Art School under P. F. Millard and between 1938-39 shared a studio in Paris with the painter and writer Michæl Ayrton. From the early 1940s he was a

included in *Radio Times* about popular radio personalities who articulated the concerns felt by all. The great global struggle was often rehearsed more effectively by Tommy Handley, Arthur Askey and Richard Murdoch than any in the all-party coalition government. Josef Gœbbels, in probably his only recorded utterance of truth, admitted that the BBC had won the intellectual invasion of Europe. *Radio Times* editors were sensitive to the popular pulse and the magazine, traditionally apolitical, though on occasions wonderfully anarchic, presented the social imperatives of a besieged nation more effectively than any didactic Ministry of Information poster, many of which became objects of derision.

In 1944, Tom Henn replaced Gordon Stowell as editor of the magazine which, in the closing stages of the European war, had been reduced to a monochromatic twenty pages due to paper rationing and shortages of ink. The German surrender in the first week of May 1945 allowed for a celebratory edition of twenty-four pages with, for the first time in many years, a full page cover illustration, in monochrome by

Terry Freeman, showing a 'V' for Victory searchlight beaming from Broadcasting House.

The Post-War Years

Where Maurice Gorham had made *Radio Times* a bright, lively and popular journal, Tom Henn's editorship reflected the austerity of the times. News of the Nazi atrocities in Europe and of the brutality of the Japanese in the Far East was published in the national press and the incomprehensible horror of genocide made levity tasteless. Paper rationing was a continually inhibiting restraint. The magazine became noticeably more serious, an example of this is the cover drawn by Eric Fraser in 1949 for a production of Gœthe's *Faust*. This wonderful drawing, now believed to be lost, is a virtuoso perspective study possessing all the bravura of Dürer's *St. Jerome* or *Melencolia 1*.

On 9th July 1945 the *Light Programme* was inaugurated and regional broadcasting on the *Home Service* wavelength was resumed. *Radio Times* accommodated the changes with a redesign that gave a

Eric Fraser, 'Faust', Radio Times, cover, 28th October 1949

James Hart, Radio Times, cover, Christmas 1939

Throughout the period, space permitting, illustrations were still an important feature of the publication. The work of Eric Fraser, Victor Reinganum, Cecil Bacon and others became perceptively darker and more intense. Although never officially 'war artists' it could be argued that these contributors did as much for the war effort as their more fêted peers, and it should be remembered that the conditions in which these illustrators worked, often in central London with its constant nightly air raids, transport disrupted and the other privations of war, in addition to the urgent, often overnight, deadlines that *Radio Times* imposed, made the commissions even more difficult to execute. Victor Reinganum, for example, drew in his spare time whilst serving as an

Tonight at 8.30 the first of two programmes will be broadcast explaining the function of the German Secret State Police—the dreaded Gestapo, the eyes and ears and brutal right arm of the Nazi regime. Tonight's programme deals with the rise of the Gestapo inside Germany.

Eric Fraser, 'Gestapo', Radio Times, 6th February 1942

auxiliary firemen in Welbeck Street, just round the corner from the *Radio Times'* editorial offices.

It is salutary, in these days of twenty-four hours a day multi-channel television satellite coverage, to remember that pre-war broadcasting was limited to the solely aural medium of radio (a television service had been available in 1936, though only in the London area and was suspended throughout the war), and that the national output of the BBC was confined to one programme, the *National,* with regional variations. In 1939 these were replaced by the *Home Service,* which became the *General Forces Programme* during the war years. Regional broadcasting ceased too as the transmitters, located throughout the UK, could have been used as direction finding aids by Luftwaffe navigators. With far-sightedness the Corporation had initiated experimental shortwave broadcasts to the Empire in 1927 and, by 1939, the BBC were broadcasting to Europe in French, German, Italian, Portuguese and Spanish, in addition to English.

This service became the only reliable source of news in occupied Europe throughout the war and it is a tribute to the integrity of the Corporation, despite great pressure from Churchill, who called the BBC, "the enemy within the gates", that its broadcasts were never subverted by the demands for the kind of propaganda presented by the Axis powers. *The Empire and Foreign Service* was to become the *BBC World Service,* arguably the finest realisation so far of the potential of broadcasting. The greatest subterfuge seems to have been the impersonation of Winston Churchill by the actor Norman Shelley who, it is claimed, secretly recorded some of the leader's great speeches for broadcast after they had been given in the House of Commons, where there were no recording facilities.

At the outbreak of war *Radio Times* staff were evacuated from their central London offices. Some went to Waterlows' plant in north-west London, others to a school nearby, or to secretly constructed offices near Evesham in Kent. Core staff remained at Broadcasting House in the centre of London.

During the war years the BBC and *Radio Times* enjoyed a unique affection amongst the British public. Whereas other British publications adopted a singularly jingoistic stance, the BBC became the unofficial, and often critical, voice of the population. People identified with the features and articles

lost the contract to print the magazine. This, to Maurice Gorham's surprise, was awarded to Waterlows, the renowned printers of currency notes, who constructed a purpose-built plant at Park Royal in north-west London especially to print the magazine. It was a much needed contract for Waterlows who had been victims of a fraud by a Portuguese confidence trickster, for whom they had printed counterfeit Portuguese bank notes in vast quantities. On the fraud's discovery Waterlows were fined over half-a-million pounds.

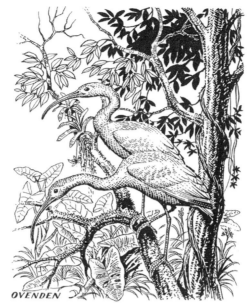

D. W. Ovenden, 'Scarlet Ibis', World About Us, Radio Times, 13th February 1969

So important to public morale was BBC radio in Britain and in occupied Europe that the Luftwaffe scheduled Waterlows' Park Royal plant for destruction. The caption to the ærial photograph in their briefing documentation specifically names it as the printing works of *Radio Times*. Maurice Gorham was present when one raid occurred, "We were nearly all of us there (in the trench shelters) when Waterlows was bombed. Two of the canteen staff were not, and I had the experience I had always imagined and never

The change of printers also allowed a re-design of the magazine. The definite article was dropped from the masthead and from 8th January 1937 the magazine became '*Radio Times*'.

Radio Times at War

Radio Times played its part in the great affairs of the epoch, the abdication of King Edward, the coronation of George VI, and the political skirmishes at home and in Europe, with editorial staff often having to change content at the very last moment to accommodate the mercurial nature of the events. Poignantly, for Christmas 1938, C. W. Hodges created the last full colour Christmas cover (p. 64) to appear for twenty-six years, an affectionately nostalgic recreation of an Edwardian street scene.

The Second World War was for the BBC, like the Royal Air Force's, its finest hour. The role that the Corporation, its programmes, staff, and *Radio Times* played in the period 1939-45 should never be underestimated.

Charles Tunnicliffe, 'Brown Hares', Radio Times, 27th June 1963

really expected - running out to give a hand with the casualties and then returning to the shelter and going on passing the page proofs."[13]

The Christmas 1939 issue of the magazine is, perhaps, the most bizarre of all. Above a scraperboard illustration by James Hart of a sprig of holly, the masthead '*Radio Times Christmas Number 2d.*' is presented in a very teutonic Gothic blackletter as if it were a seasonal issue of *Der Stürmer*.

In 1941 Gorham left his *Radio Times* editorship on being offered the opportunity of running the BBC's North American Service. His deputy Gordon Stowell was promoted to acting editor, with Douglas Græme Williams as acting deputy editor. Paper rationing reduced the size of the magazine, sometimes to as few as twenty pages. Circulation also suffered, in that year it was as low as 2.28 million. However, by the end of the war, with radio broadcasts the only safe form of mass entertainment, the magazine reached sales figures above 4 million.

speculative illustrations directly from illustrators as often as by commission. Ardizzone's style reflects the drawings by the great Dickens' illustrators, his cross-hatched pen lines emulate the pattern achieved by the steel engraver's burin; however, where those artists depicted the grim scenes of Victorian life, Ardizzone's looser treatment allows for more playful characterisation. He was an obsessive sketcher.

BATT, 'Bach at Köthen', Radio Times, 29th July 1937

Interviewed in 2000, by Joanna Carey in *The Guardian*, his daughter says that her father rarely drew from life for his illustration work, "…except in formal life classes: he did all his drawing from memory, drawing what he'd seen half-an-hour before. And I have a theory that the speed and fluency of his drawing was partly due to the fact that he had a bit of a stammer - drawing was a much easier form of communication."[11]

C. W. Bacon, 'The Queen's Return', Radio Times, cover, 7th May 1954.
Courtesy Victoria and Albert Museum

With Percy Scholes on the staff it was inevitable that music broadcasts were featured prominently in *The Radio Times*. BATT, the pen name of Oswald Charles Barrett, began contributing to the magazine in 1930 where, for fifteen years, his drawings of famous composers and musicians became so popular that *Radio Times* published reproductions for framing.

One of the most prolific illustrators, C. W. Bacon, began working for *The Radio Times* in 1935. His use of scraperboard,[12] the medium he used almost exclusively throughout his long association with the magazine, never allowed the medium to obscure the meaning of what he wished to communicate. Virtually self-taught, and seemingly oblivious of movements in art history, he showed interest only in what other contemporary illustrators were achieving. Like others from Dürer onwards, he used a *camera lucida*, an optical device he used to trace reference material to the scraperboard. Recently David Hockney has made much of his 'discovery' that artists have used this instrument, however *'Lucy'* and her forbears, have been a familiar presence in artist's studios since the Renaissance.

Scraperboard was also used by Charles Tunnicliffe when topographical or wildlife subjects were required for illustrating *Radio Times* features. Charles Tunnicliffe contributed accurate studies of wildlife from his home in Anglesey. His wood engravings for *Tarka the Otter* (1934) launched his career as a book illustrator, however, his prowess as an etcher - producing landscapes that reflect an obvious love of Rembrandt - was equally admired.

Another celebrated wildlife artist, Denys Ovenden, began working for *Radio Times* in the early 1950s. He contributed many distinguished illustrations for BBC radio and television features, including Peter Scott's *Look* and *The Naturalist*. He is now, and with great generosity, passing his expert knowledge of drawing natural history subjects to a younger generation.

By 1936 *The Radio Times* had achieved circulation figures of three million copies a week, returning profits of £400,000 a year. In this year Newnes and Pearson

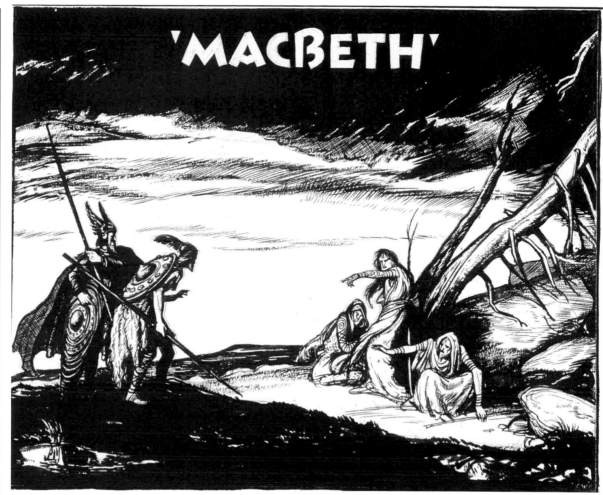

'MACBETH'

O. Walter Hodges, 'Macbeth', Radio Times, cover, 10 March 1933

myself to be a 'jobbing artist.' The odd thing about being an illustrator of magazines is that one was somehow cut off from the physical reality of the drawings themselves. I was frantically eager to collect [them] as published, to use as specimens. I paid little or no attention to [the originals]. Actually I believe my earlier originals were such a mess of whiting out and re-drawing that I think they might shame me now. Doing them, by whatever tricks, means and methods, was really how I learnt to do it at all, and it involved an awful lot of sitting up all night to catch the early morning train and my deadline. I look back on it with amazement. I have always felt more at home with writing than drawing. And the theatre. I always wanted to be a stage designer."[10] In fact Hodges became an expert on the presentation and stage devices of Elizabethan theatre, the author and illustrator of many books on the subject; and his (unpaid) authority leant verisimilitude to Sam Wanamaker's epic construction of the replica *Globe Playhouse* in London.

During the first two decades of *The Radio Times* Maurice Gorham and Douglas Græme Williams assembled a repertory company of illustrators who could be relied upon to deliver work of substance and to deadline. Each artist almost became categorised by subject, Fraser, after his initial humorous period, for

Edward Ardizzone, Radio Times, cover (detail), Christmas 1948

classical features, and Reinganum where fashionable illustration and hand-drawn lettering was required.

In 1932 Edward Ardizzone, who had known Maurice Gorham as a child, began his long association with the magazine. At this time the protocol was that Gorham bought

Arthur Watts, date and title unknown, Radio Times. Collection Luke Gertler

official war artist, that prefigures the work of Anselm Kieffer and now hangs in Tate Modern.

Artists possessing more traditional styles were also encouraged. Both Rowland Hilder and C. Walter Hodges studied at Goldsmiths' College under E. J. Sullivan. Hilder was born in New York and came to England with his family at the age of ten in 1915. He contributed occasional sketches from life, remarkable for their draughtsmanship and use of perspective. Also remarkable is the fact that in spite of - or perhaps because of - his American roots, Hilder's watercolours of the British countryside, especially that of Kent, became the most popular reproductions of this nation's landscape in the 1950s and 60s.

mirrors the dynamic cultural and political changes that occurred in western Europe during the inter-war years.

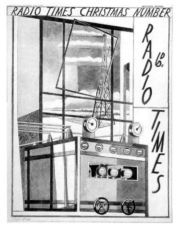

Paul Nash, Radio Times, cover, Christmas, 1930

This highlights a paradox of creativity: great 'fine' artists are not automatically good editorial illustrators. An example is the surrealist influenced Paul Nash (1889-1946). His cover for the Christmas 1930 edition of *Radio Times* is a futurist antidote to every seasonal cliché. It features an ærial mast behind a brutally metallic broadcast console. There are echoes of the Italian Futurists and also of Mondrian (on a bad day). Nash, perhaps freed from editorial constraints and tight commercial deadlines, is seen at his greatest in such works as the dolorous *Totes Meer*, created whilst an

Hilder also presents a chilling indication of the early awareness in Britain of Nazi Germany's sinister intentions. For the 1935 Christmas edition of *Radio Times* - only two years after Hitler had seized power - he made a drawing of a German concentration camp for a broadcast feature called, *'Twilight of the House'*. This bleak drawing, certainly not representative of Hilder at his best, and possibly made in a great hurry, hopefully rang alarm bells in the minds of contemporary readers of the magazine.

The influence of Frank Brangwyn - one of the most under celebrated artists of the twentieth-century - can be seen in the work of both Hilder and C. Walter Hodges. One of the great British illustrators of the twentieth-century, Cyril Walter Hodges has always, and with great diffidence, regarded his magazine work as subordinate to his illustration for books and his theatrical interests. Writing in 2000, Hodges recalled "I was and considered

Rowland Hilder, 'Twilight of the House', Radio Times, Christmas, 1935

successfully. It was the fine tradition of English black and white drawings, brought to perfection by Thomas Bewick, Hablot Knight-Browne, Edward Calvert, and John Tenniel in the eighteenth and nineteenth centuries, and maintained by those like Edward Ardizzone, Eric Fraser, Robin Jacques and Lynton Lamb, in the twentieth, that were the æsthetic ideals emulated, and often equalled.

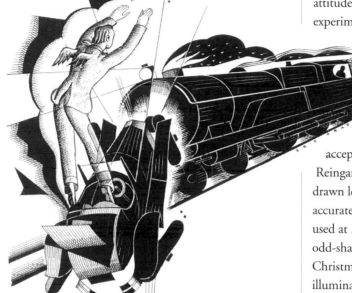

Eric Fraser, 'The First Second', Radio Times, 1929

An artist who created one of the most idiosyncratic and poetic styles was the reclusive Eric Fraser who began drawing for *Radio Times* in 1926 and continued until 1982, when assistant art editor Sue Aldworth commissioned one of his last illustrations, *The Flying Dutchman*. His last *Radio Times* cover, for Tolkien's *Lord of the Rings* broadcast in 1981, proves that none of his skill had diminished.

Fraser became a stalwart of *Radio Times'* illustration stable, his iconoclastic style is identified with the interpretation of classic plays and features of great moment. Throughout the 1920s and early 30s, however, he contributed mostly humorous drawings, although by 1929 he

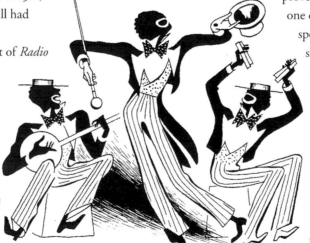

Victor Reinganum, 'Minstrels', unused, Radio Times, June 1964

began producing the outstanding work in the style for which he will always be remembered.

Ancient and Modern

The *Radio Times* illustrative style is a moveable feast, it reflects the cultural sensitivities and creative audacity of successive art editors. There has always been a rare attitude within the art department of continual experimentation, where artists possessing new ideas and often radical techniques are published. One such was Victor Reinganum perhaps the most avant of all the avant-garde illustrators of the time. He had studied art in both London and Paris, one of only six students accepted for tuition by the cubist painter Léger. Reinganum's great skill was in incorporating hand-drawn lettering, often reproducing a typeface accurately within his illustrations. This ability was well used at *Radio Times* when it came to designing the odd-shaped headings for the year's festivals, Easter, Christmas, etc., where a long, horizontal banner illuminated the top of the page. The art editors at *Radio Times* always delighted in commissioning these odd-shaped illustrations that required great imagination to fill convincingly. The precision and cleanliness of Reinganum's final artwork points to his very disciplined working practice.

Throughout these early years illustrations reflecting modern styles were published alongside more traditional forms. Cartoonists from the national press, Fouet, Sheriffs, and Watts, were regulars. Arthur Watts proved a diligent contributor, on one occasion, during a winter sports holiday in Poland, he skied twenty miles to the nearest post office to submit his work. On rare occasions even Royal Academicians such as Frank Brangwyn contributed, an indication of the authority and respect that the magazine had won. That *Radio Times* was able to present this disparate gallery of art is remarkable, though it

office of the lady who ordered the blocks from which the magazine's illustrations were printed. His appearance, tapping on the window to gain entry, understandably shocked her. Later, when she said that a block could not be engraved in time, Gorham repeated his parapet walk, threatening to jump if the block was not cut. He and Græme Williams encouraged horseplay. One of art agent R. P. Gossop's representatives, Jack Wall, a keen rugby player, complained about fees and, after an argument, ended up wrestling on the floor with Gorham and Græme Williams, before being thrown out into the corridor. These 'fights' were a regular occurrence, until one of the combatants fell and narrowly missed hitting his head against a filing cabinet. Thereafter Maurice Gorham banned fighting, suggesting that, "it would look bad if one of them got killed."[8] This informality was also present in broadcasting of the time, on Good Friday, 1930, listeners in the evening were told, "There is no news." Piano music was broadcast instead.

Fees, however, have always been a bone of contention. Throughout its history *Radio Times* paid illustrators substantially less than other commercial publications, and it is remarkable that the work should have maintained such a consistent quality; although, in the early days, the illustrator Victor Reinganum recalled receiving three guineas for each drawing and being able to live comfortably on six guineas a week. In 1927 a dozen eggs cost 1s.6D (about 8p), and a pound of cheese cost 1s.4D.

Reinganum's fees, however, contrast with the BBC's General Manager, John Reith receiving, somewhat nepotistically, six guineas per thousand words to write a weekly column, even though Reith began what he called 'an awful plague' on a purely pro bono basis. There was, however, an enlightened attitude that demonstrated the paternalism of the Corporation towards its staff. After ten years in a responsible

creative position, senior employees were encouraged to take paid sabbatical leave. Gorham mentions that the idea, called *'Grace Term'*, was to give people a chance to get away from their work more thoroughly than they could do on an ordinary annual holiday, and the benefit that the BBC looked for was the general effect of new ideas on staff. Gorham was given £100 and travelled throughout the United States in 1938.

The art of *Radio Times* reflected the æsthetic of its time. Illustrations in early issues embraced all the contemporary isms: Vorticism and Futurism rubbed shoulders with vernacular cartoon drawings and the graphic styles of earlier centuries. Later, Surrealism, Pop Art, and even conceptual trends were acknowledged.

Radio Times, under Maurice Gorham's direction, encouraged a radical commissioning policy. In 1948 Gorham recalled, "We had covers designed by artists from every school, from Frank Brangwyn (who did us a superb Christmas cover of the Three Wise Men) to Austin Cooper, besides giving most of our regular artists a chance at something more showy than their usual work. Ardizzone, Eric Fraser, Reinganum, Althea Willoughby, and C. Walter Hodges are those whose colour work I remember well."[9] Eclecticism has always been allowed in *Radio Times*, where the rigidity of its formatting creates enough discipline for the inclusion of the most disparate graphic styles.

The style of black and white line illustration published by *Radio Times* began almost as a practical necessity. As the paper used to print the magazine was cheap absorbent material it could not easily accept the subtleties of mechanical halftone screens. Photographs were used from the earliest issues however, these rarely reproduced as well as drawn illustrations. Black line images - derived from either pen line drawings, scraperboard, lino or wood cuts and engravings - were the only graphic techniques that reproduced

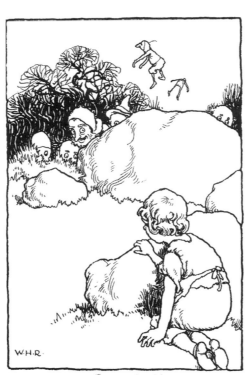

W.H.R.

WATCHING FOR FAIRIES No. 2

William Heath Robinson, 'Watching for Fairies',
Radio Times, 1938

all his other duties with an increase to his 'very exceptional' salary - he had been given £400 a year on his appointment. Nicolls refused and Gorham staged what he described as 'a little sit down strike', it was the year after the General Strike of 1926. When Maschwitz or Nicolls asked about illustrations, Gorham replied that it had nothing to do with him. He was, however, secretly choosing the graphic content in collaboration with Douglas Græme Williams. The subterfuge worked and by the end of 1927 Gorham was officially art editor, with an increase to his salary.

Maurice Gorham established a mandate for the magazine's graphic excellence. Like subsequent art editors he possessed an intuitive ability to encourage embryonic talent and to predict trends. "We began with a small group of artists and agents - mostly agents - that we inherited from Fuller's day, but soon began to branch out, and before very long we were probably the most catholic illustrated paper in the country. We used old hands like Stephen Spurrier and Forster and Arthur Watts; I even had the thrill of ordering drawings from my boyhood's idols like George Morrow and Alfred Leeke. But we welcomed new men, too; very often before they had got any other work...Eric Fraser, Victor Reinganum and Ted Ardizzone were among those who, I believe, worked for us before any other art editors used them."[4]

Typography and layout were also Gorham's concern, "In one way, the most interesting part of our work was dealing with type. There was no intermediary between yourself and the result, once you had got the printers to follow your instructions. In those days new types were coming out daily, and we had a lot of fun with the Fanfares and Neulands and Gill. I got a real kick out of reading a script, settling on an illustration, giving the job to an artist, and then doing the type display to go with it."[5]

An indication of Gorham's commitment to fine art, and of Percy Scholes' support of new music occurs in an issue of 1929 where an entire section of eight pages, with an article, 'The Art of Etching' by James Laver, is devoted to reproductions of etchings, one even by Randolph Schwabe, on the theme of broadcasting. This was printed in sepia. In the same issue a double-page spread gives the score of Peter Warlock's 'The Frost Bound Wood'.

The BBC furthered its cultural activities by publishing The Listener, 'The BBC Literary Weekly'.

This was launched on 16th January 1929 and commissioned illustrations from many Radio Times artists.

Eric Maschwitz left Radio Times in 1933 to pursue a career in the theatre and John Reith offered the editorship to Maurice Gorham. Again Gorham showed great acumen. During an interview with Reith, who seemed more concerned with Gorham's religious and political ideals, asking, "Are you a Communist?", the Director General offered him the editorship at no increase in his salary, but with a commission on results. Gorham ingeniously accepted, on the proviso that he should also be given control of programmes. This unsettled Reith who replied that the suggestion had not been meant seriously. Gorham pressed his advantage by naming his salary. He also asked that Douglas Græme Williams should be promoted to art editor.

Maurice Gorham described his editorial philosophy in 1934, "The two-fold function of The Radio Times is, I take it, to achieve the largest possible circulation and to give the most helpful kind of service ancillary to broadcasting. For both these purposes, it is essential to consider the really average listener; the person we have been accustomed to personify, in the office, as 'the cabman's wife'. This really average listener will probably buy the paper primarily for the programme pages; that is why they will always remain the backbone of the paper to make such listeners read as much as possible of The Radio Times, and to make what they read there help them to understand and appreciate their broadcast programmes is our obvious goal. To attain it, it is necessary to avoid being highbrow but not necessary to be cheap."[6] Remarkably, during his editorship of The Radio Times, Maurice Gorham did not possess a radio at home.

The working ethos within the editorial department of Radio Times at the time was relaxed. In spite of John Reith's attempts at imposing the highest moral standards within the company. Maurice Gorham recalled "I never knew an office where sex played so large a part, where so many people lived with their secretaries."[7] Gorham, with his Irish background, possessed a truly creative sense of humour. One day finding himself without a key and locked inside his office, Gorham opened a fourth floor window overlooking Savoy Hill, climbed out onto the parapet and walked round the building to the window of the

borders, especially during the fifties. The subtleties achieved by changes in typefaces and print technology were designed to improve legibility, however any alteration was frequently met with vehement opposition from its readers.

Initially illustrations were restricted to a single page entitled, 'People you will hear this week', but feature articles were illuminated, either with photographs or drawings. The cover for the first Christmas edition was printed in full colour. The artist Kay painted a family huddled in dangerous proximity to a blazing hearth, listening to a horn wireless. This set a seasonal precedent that became a traditional feature of *Radio Times*, and the British Christmas. In 1926 the American designer Edward McKnight Kauffer was commissioned to design a cover - as controversial a choice as if a recent Christmas issue had been designed by Damien Hirst. The image was an abstraction of a lightning flash linking the Holy Star to a silhouette of St. Pauls in London (p.14). Curiously, for a piece by one of the seminal avant-garde graphic artists of the time, influenced by the vorticist Wyndham Lewis, the modernity of this illustration is anachronistically tempered by the inclusion of a illusory baroque cartouche enclosing the words '*The Radio Times*'. This cover was opposed by Newnes, still co-publishers, however it outsold the previous three Christmas issues, and the radical artist was invited to create another the following year. In this the seasonal elements, bells, stars, dove of peace, are apotheosised into a futurist design, although with an art deco gloss. One of the greatest French poster artists, A. M. Cassandre, contributed a cover for Christmas 1928, an indication of the lack of xenophobia within *Radio Times*.

In 1926 Walter Fuller followed Leonard Crocombe - who had continued editing *Tit Bits* in addition to *The Radio Times* - as editor. Fuller, who once absentmindedly lost the corrected proofs of an edition on the London Underground on his way to the printers, initiated changes to the design of the magazine, allowing the accommodation of much more illustrative content. From 1926 illustrations, either photographic or drawn, were employed to decorate the pages. They were an important editorial feature and, given the intricacies of formatting such comprehensive and complicated page layouts, have always been a useful device where text runs short and column space has to be filled. In June that year Maurice Gorham

(1902-75) joined the magazine as assistant editor. Educated at Stonyhurst College, Lancashire, and Balliol College, Oxford, he had previously worked with Fuller on the *Weekly Westminster*. His responsibilities included writing about all the non-musical broadcasts, "From a skeleton billing, one or two names cast, and a knowledge of the producer, I could glean enough to write about and order illustrations for any show." he wrote, "But that was a last resort. I still spent hours hunting producers, who one and all love publicity but hate getting down to details about what they are going to do. It was here that the secretaries came in...they were very clever; and whatever else they did, they did the work of two men. If I wanted to find out all about a forthcoming programme, I would be more likely to find the secretary in the office than the producer, and luckier too. Not only was it more pleasant, but she would know more."[3]

Maurice Gorham ©BBC

Fuller held the editorship for only one year. In 1927, aged 46, he died suddenly and John Reith appointed the multi-talented Eric Maschwitz (subsequently to achieve fame as the composer of songs such as *These Foolish Things, Goodnight Vienna,* and *A Nightingale Sang in Berkeley Square*), as acting editor. At this time *Radio Times* staff also included the musicologist Percy Scholes, later to edit *The Oxford Companion to Music*, and Val Gielgud, brother of the actor John. It was by all accounts an idyllic and cultured working environment.

The general editor was Basil Nicolls. He had been an administrator in India and the BBC's station director in Manchester and London but had no experience of publishing. Maurice Gorham was one of the first to clash with him. The responsibility for choosing illustrative content for the magazine had been shared by Walter Fuller's lady assistant and Maurice Gorham. When she left the BBC, after Fuller's death, Gorham approached Nicolls with the entrepreneurial suggestion that he should be appointed art editor, but also retain

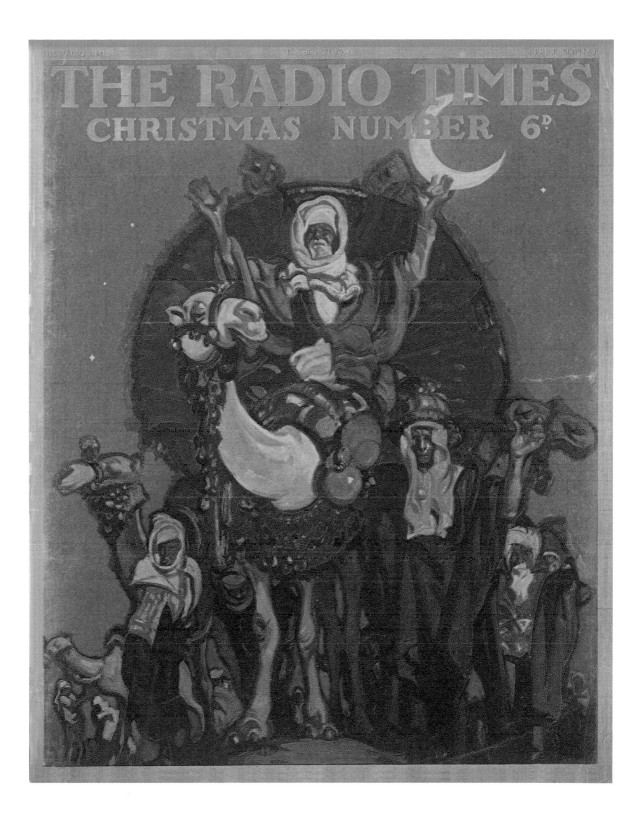

Frank Brangwyn,
Radio Times, cover,
Christmas, 1934

Artists of Radio Times

ON THE 28TH OF SEPTEMBER 1923 an entirely new kind of magazine was launched. It was published initially from offices in Strand and later in Savoy Hill, London. It carried details and transmission times of radio programmes broadcast by the newly formed British Broadcasting Company - it became a Corporation in 1927. The new journal was *The Radio Times*, it cost 2D, and was General Manager John Reith's response to newspaper proprietors who demanded payment for publishing programme details, perhaps fearing with accurate prescience, the competition that radio would give to printed media.

Strangely, for a publication identified solely with the BBC, *The Radio Times* was published in partnership with George Newnes, on a profit-sharing basis, for the first few years. Newnes also retained editorial control, the BBC merely supplied details of programmes. It was not published under the complete editorial control of the BBC until the 19th February 1926. The puritanical Scotsman John Reith (1889-1971), the son of a Presbyterian minister, regarded *The Radio Times* as a kind of railway timetable (with evangelical overtones) merely to guide the listener.

From its inauspicious launch the magazine has become an inestimable document of the past century's social and cultural history in Britain, a unique weekly inventory of taste and stylistic influences. From the beginning *Radio Times* contained illustrations, either photographic or drawn. The drawings, many created by the finest artists of the time, are as valuable a record of the twentieth-century as any images in the great photographic libraries. As Asa Briggs commented in 1981, "Whatever the structure or the date, however

John Reith ©BBC

before or after 1955 the illustrations in the *Radio Times* are as revealing to the historian of society and culture as are the programme announcements and the articles about them."[2]

By 1932 the BBC had outgrown the offices at Savoy Hill and moved to the newly purpose built Broadcasting House in Portland Place, London. *The Radio Times* prospered and in 1933, ten years after its launch, had a circulation of two million, the revenue from which represented over one quarter of the BBC's annual income from licences.

The first editor was Leonard Crocombe, given just seven days to bring the launch issue out, who had made Newnes' *Titbits* into a successful magazine for proprietor Lord Northcliffe. He brought with him the skills of popularisation to the creation of what was an entirely new type of journal. Crocombe, an enthusiastic advocate of broadcasting, ensured that John Reith's lofty proselytism was tempered by an awareness of the less elevated tastes of the majority of the BBC's listeners. The inaugural issue sold over two hundred and fifty thousand copies.

The layout was chosen as an exigency. Because of the limited time the editorial team had before press day, the luxury of creating an original design was denied and Crocombe was forced to instruct the printer to follow the style of another Newnes' periodical, *John o'London's Weekly*. The hand-drawn '*The Radio Times*' masthead on the cover is redolent of contemporary vernacular comic scripts. The programme details were given following the style of contemporary theatrical programmes.

Throughout its seventy-eight year existence *Radio Times*' design format has remained substantially unaltered. The features and programme details were set in columns, at periods in its history separated by rules, with the changes limited to areas of the page spread for different programmes and, with the arrival of television, sequential and non-sequential pagination for radio and television listings. Important features were illustrated and displayed by being given decorative

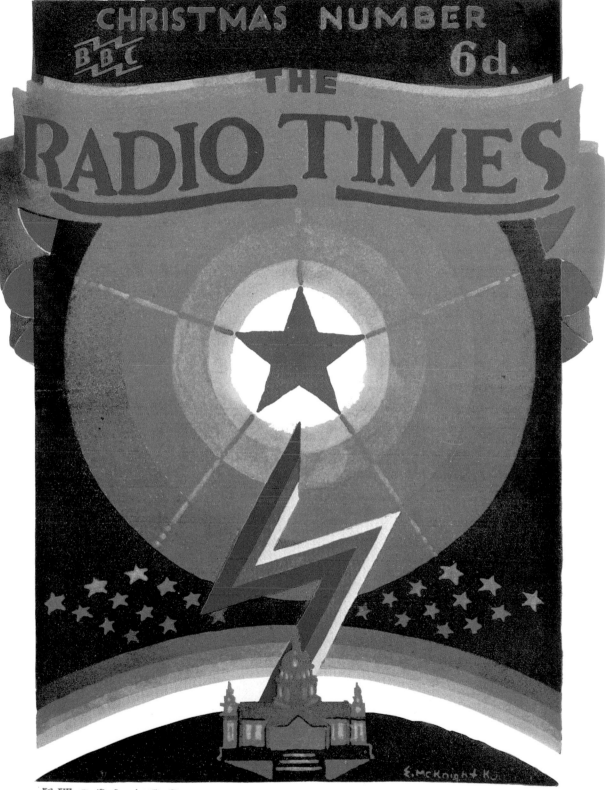

Vol. XIII. No. 168. December 17th, 1926. Registered at the G.P.O. as a Newspaper B.

Edward McKnight Kauffer,
Radio Times, cover,
Christmas 1926

De Humani Corporis Fabrica, in 1543, publishing a series of poetic engravings, possibly drawn by Jan van Kalkar, a student of Titian. This collection, created during the waning of the Renaissance in Italy, is a fusion of art, science and humanist philosophy.

At Wolfenbüttel, Germany, Michæl Prætorius published his *Thætrum Instrumentorum* in 1620 as an appendix to *Syntagma Musicum*, with wood cuts that give the scale, proportion and shape of contemporary musical instruments. This has become an essential resource for research into musical practice of the late Renaissance.

In the eighteenth and nineteenth centuries the sophisticated possibilities offered by wood and steel engraving and etching upon copper plates allowed refined possibilities of line and tonal texture. In France, Gustav Doré made drawings for a French edition of Dante's *Divine Comedy*, that became the definitive Romantic images of Hell. From these engravers produced miraculous facsimiles of his originals.

George Cattermole, 'Master Humphrey's Clock', by Charles Dickens, 1840. Collection Martin Baker

In Britain, Bewick and later Hablot Knight-Brown, George Cattermole, George Cruikshank and John Tenniel exploited these technical advances to perfect the style of narrative illustration. The genre reflects the genius of the Elizabethan miniaturists.

British narrative illustration rarely attempted the grandiloquence of Dürer or Doré, still less the barbarism of Goya, it belonged to a style of graceful reserve, yet often vulgar quirkiness. It is significant that the further north you travel in Europe the more concentrated the physical size of works of art become. At our latitude we focus upon minutiæ. The Devil is in the detail.

Placing the craft of the illustrators featured in this exhibition within the chronology of great art demonstrates a reassuring continuity of classical practice. It is a sad paradox, given the lack of respect given to commercial illustrators, that the craft of Raphæl, Titian and Rembrandt has been kept alive almost exclusively by artists working in the sphere of commercial publishing, beyond the much-hyped art establishment's ægis.

Back to the Drawing Board?

The post-war years were a fecund crucible for the arts. In the vacuum caused by the chaos of reconstruction the most fundamental principles were questioned. The existentialism of Kierkegaard, Heidegger and Sartre was a conduit that posited acceptance of the subjective, a difficult concept for the British who prize objectivity and rationalism above all. Later, Noam Chomsky sensitised us to the political consequence of language. A seminal influence in the 1950s, though largely misunderstood at the time, was the Canadian philosopher Marshall McLuhan whose prophetic vision of a global village, where the medium is the message - realised by today's internet technology - became a trite media excuse for substituting style for substance.

The straw that has broken the camel's back of our cultural life has been the introduction of satellite and cable technology, and the rise of crass popularisers. Forget Lenin, these are the real dictators of the proletariat.

The internet will complete the dumbing down of the medium, as the technology to access the world-wide web will soon be incorporated within domestic televisions, and be as easy to use. It is typical that this technology should have arachnid connotations, for we, the consumers, are certainly the flies! The media of the future will maximise profit, with offerings of bread and circuses - pop and prurience.

History repeats itself, for these same banal influences gave the early printers their wealth.

13

illustrators, highlights a feature of the profession that John Lord remarked upon recently, "Illustrators are, on the whole, nice people". It is certainly true that without their altruism much outstanding work would never have been completed, given the inadequate fees paid by publishers. The recent severe recession within publishing has certainly resulted in a substantial reduction in fees and in the commissioning of original hand-made work.

Airwaves

Until 1955, with the advent of independent television, the BBC enjoyed a monopoly of broadcasting and radio was the only medium available to the majority. Initially BBC television, inaugurated in the London area in 1936, showed little promise of what it would later achieve.

Although the Coronation in 1953 proved television's superiority over radio, the wireless mandarins at Broadcasting House looked down upon their television counterparts at Alexandra Palace.

Within a few short years the early phosphorescent incunabula of dross was slightly ameliorated by television producers responding to the liberating, interrogative climacteric of the sixties (was it coincident with the 1961 election of Kennedy and his empowerment of a youthful electorate?). The medium became serious, with programmes that changed lives: *'Cathy Come Home'*, in 1966. *Panorama* and *This Week* also established a responsible and mature attitude to the possibilities for political and ideological change afforded by the medium.

The most poignant and moving example occurred in Jacob Bronowski's *The Ascent of Man* in 1973 when the scientist, crushed by the memory of tragedy which surrounded him, gently knelt to let the familial dust of Belsen trickle like blood through his

Jacob Bronowski ©BBC

fingers. This silent visual analogy with time is a sequence that speaks a thousand indelible words.

There were also Kenneth Clark's *Civilisation*, and Huw Weldon's arts series *Monitor* that promised a cultured future for the medium. Presenters, too, credited their audience with an intellectual grasp. One of the finest was James Mossman, a great television reporter whose experiences of reporting the war in Indo-China perhaps lead in no small way to the tragedy of his early death in 1971. Mossman imbued his *Monitor* features with a self-effacing moral

James Mossman ©BBC

authority that is absent today, where presenters - the braggadocio mediums - are very much the self-aggrandising message.

Mossman's last appearances were as editor and presenter of *Review*, which began on 6th September 1969. He was a gifted novelist, with an interest in painting and had a healthy cynicism for the cultural appetite of Britain, "In Britain, unlike France or Russia," he wrote, "a contempt for the arts is something the socialist politician shares with the aristocrat."

The Medium, the Message

The miniature monochromatic drawings within text, such as the illustrations published by *Radio Times*, had origins which lie in the vernacular chap books and broadsheets published at the dawn of printing. These developed through the woodcuts of artists such as Dürer, who, while working in the studio of Michæl Wohlgemut, may have contributed original designs to Hartmann Schedel's *Liber chronicarum*, a history of the world and one of the most beautiful books ever produced. Printed in Nuremburg by Anton Koberger in 1493 this elevated history of the world contrasts with Giulio Romano's sixteen pornographic etchings for which he had to flee to Mantua in 1524, excommunicated from Rome.

In the sixteenth century the anatomist Andreas Vesalius (1514-64) synthesised science and art to produce the first modern book of human anatomy,

photograph within an advertisement layout. Pulling out a reproduction of, perhaps, the *Polish Rider* by Rembrandt he would indicate by analogy, that the Dutch master had a similar problem in placing the horse within the landscape. It was inspired teaching, and made us value the prosaic nature of our studies. It also gave us a vivid and more profound awareness of

Harold Cohen, 2001

art techniques, æsthetics, and art history than any lecture. His ability to illuminate and inculcate intrinsic artistic values, with examples from the earliest times to our contemporaries, was enhanced by our respect for his own abilities as a painter and draughtsman, and his work today possesses rare qualities of æsthetic integrity.

The other influence was George Hooper, a fine and neglected landscape artist. His life drawing classes taught us as much about life as about drawing: in (innocently!) chasing a naked model around the studio he forced us to make quick sketches, on the run. He encouraged us - long before Damien Hirst - to use found materials and experiment with all mediums to create our inchoate art. One really unforgettable morning his daughter visited and played pieces by Rameau upon the college's old upright piano whilst we worked, a reminder that the visual arts do not exist in a cultural vacuum.

We were encouraged to view *Radio Times* as an arbiter of excellence in terms of illustration. At its height, from the late 1940s to the end of the 1980s, the artists who contributed to the magazine had the greatest impact and influence. Their work is distinguished by draughtsmanship that bears comparison with drawing of any epoch. Other magazines, like *John Bull*, included outstanding examples of colour illustration, as fine as any of the

graphic work published by *The Saturday Evening Post* in the United States.

The decline of these crafts is a result, partly of inexpensive colour printing, but also of the dumbing down of image creation afforded by computer programmes - publishers no longer require refined skills in drawing and art editors today seem intimidated by work produced by pencil, brush, cutter or burin. Clip art prevails.

I began drawing for *Radio Times* in 1974. I had always wanted to illustrate and, after ten years working at Ogilvy and Mather as a copywriter, graphic designer (and frustrated illustrator), the creative director, Stanhope Shelton, sent me to his wife, a director at Ginn, the educational publishers. She courageously gave me my first commission.

The poet Assia Wevill gave me further encouragement as I worked on a children's book - still unfinished - *Wellington the Tin Soldier*. Then, in 1973, Gabrielle Stoddart took my folder of drawings to *Radio Times*. Later, at one of the magazine's Christmas parties, I met Robin Jacques.

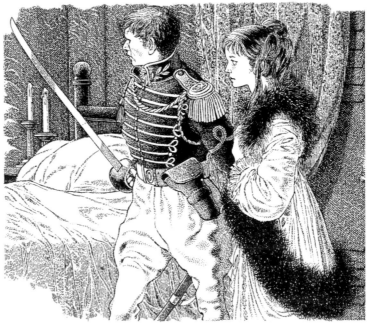

Robin Jacques, 'Arms and the Man', Radio Times, 22nd April 1960

As many of those who knew him will attest, Robin was modest in appreciation of his own achievements, yet very supportive and encouraging of those in others. He was enthusiastic about modern jazz and modern art (an illuminating guide during a visit to the Saatchi gallery). His generosity towards other, younger

by referencing Brunelleschi's transcendent interior for San Lorenzo in Florence). Art has become a marketable commodity of half-baked ideas, executed by sleight of hand, rather than an adjunctive utility of profound cerebral reflection. The patrons, dealers, and curators of this Emperor's new wardrobe have leant their questionable authority to this delusion.

This is not to rehearse the Ruskin-Whistler case, it is simply that conceptualism, minimalism and all the other cynical excusisms for what passes as art today are cultural culs-de-sac, into which the bland are lead by the bland. They have more to do with the triviality of the fashion industry than art. The public appetite for the grotesque is sated by the *Grand Guignol* of this new Victorian freak show, *'...cum tumultuositas vulgi semper insaniæ proxima est.'*

Art School

The malaise begins at art school. The students that I encountered as a tutor were encouraged to destroy rather than to construct. In these schools of destruction, for that is what most art colleges have become, it is not the winning that counts, but the taking apart. The habit sticks. Traditional skills are no longer included in the national curriculum. Drawing from life, lessons in anatomy and perspective, the craft skills of painting and printmaking have been largely abandoned in this apology for art education, to be replaced by easily assimilated processes, especially those afforded by computer image creation (and if it cannot be done with the computer by this younger generation they cannot do it!). There were among my students a few who exhibited real talent in drawing, but they were in their first year, before other tutors had crushed such reactionary dexterity from them. As for art history, when a dozen or so students were asked for the name of the artist who painted the ceiling of the Sistine Chapel only one offered an answer - '*Leonardo?*'. Art History, it seems, is bunk for today's youth.

This exhibition is, after being a homage to an exceptional period in British art, also a plea for the return of those traditional disciplines within the national art education syllabus, life drawing, studies in

perspective and colour theory and, especially, lessons in art history. Without these essential building blocks the construction of a substantive arthouse of the future will be a matter of luck rather than judgement. Fortunately there are a few art colleges that have re-introduced these disciplines into the curriculum.

Studying 'commercial' art at college in Brighton during the late 1950s I was fortunate to have tutoring by Gaynor Chapman, one of the most stylish illustrators of the time; C. Walter Hodges, whose encyclopædic knowledge of Elizabethan theatre gave his work verisimilitude; there was also the idiosyncratic

Cyril Walter Hodges, 2001

John Vernon Lord, the only artist I know to make the rigidity of a *Rapidograph's* stylus dance. Recently retired from the University of Brighton, this distinguished Professor of Illustration, and one of Britain's leading illustrators, spoke of the craft as being the 'art of the people' in a lecture given at the University in 1999, "The fine arts are allowed to be obscure and bewildering but illustration is not. Narrative illustration and context (that is image and text) are bound up as one, whereas I believe that the products of fine art should be capable of speaking for themselves...and of revealing their own significance, without the crutch of context or commentary. Although, I must say, I am not sure if that is the case these days when I look at the huge quantities of contextual paraphenalia, justification, rationale, and explanation that seems to go into contemporary art exhibition catalogues and reviews these days. It seems that in art's case a plethora of text matter is generated, as a post-script, *after* the art has been made...".

Two people, however, made the greatest impression, the first was the finest tutor of art that I have ever encountered, Harold Cohen, who taught graphic design and carried about with him a pocket full of postcard reproductions of works of art. Harold, who had studied and worked with Henrion, used these to convey solutions to our somewhat mundane graphic design problems - for example, the placing of text or

'Nec audiendi sunt qui solent docere, 'Vox populi, vox dei'; cum tumultuositas vulgi semper insaniæ proxima est. - Nor should we listen to those who say, 'The voice of the people is the voice of God', for the turbulence of the mob is always close to insanity. *Epistolæ*, ALCUIN, 735 - 804.

Art and Delusion *Martin Baker*

THE TRADITION IN ART, exemplified by the craftsmanlike drawings commissioned by *Radio Times* since 1923, has been, at the beginning of the twenty-first century, corrupted by ugliness and vacuity. Artists today are encouraged to return to the Cimmerian gloom and, rather than looking at the stars, take the detritus in the gutter as stimulus for their work. Fortunately the sun shineth upon the dung hill and is not corrupted.

The twentieth-century elevated the infantile at the expense of intellect. Ever since Duchamp raised the puerility of scatology to fashionable iconic status the infantile became one of the motive trends of the century. Sigmund Freud promulgated this, Marcel Duchamp exploited it. From his fountain flowed a thread of immature excrescent banality to the current conceptual charlatans whose bodily fluids have become today's turpentine and linseed oil of art mediums. Raphæl said that the object of the artist was to disguise the art. These parvenues have so successfully disguised the art that it has become invisible.

Victor Reinganum, 'The Temporal Areas'
Radio Times, 2nd March 1951

Tom Stoppard, in a speech last year at the annual dinner of the Royal Academy of Arts, actually clarified the problem when he suggested "that a fault line in the history of art had been crossed when it had become unnecessary for an artist to make anything, when the thought, the inspiration itself, had come to constitute the achievement." Significantly in this time the United Kingdom also substantially lost its own manufacturing tradition.

James Hyman, in *The Battle for Realism*,[1] suggests that Emin, Whiteread and the Chapman brothers are the artistic descendants of Francis Bacon and Lucien Freud in their use of extreme physical experience as artistic expression. This argument is tenuous and only sustainable in the sense that the sap rising in the trunk of a tree in spring leads inevitably to the fall of the dead leaves in autumn. Even the Chairman of the Institute of Contemporary Arts, Ivan Massow, was recently forced to resign after describing their work as "pretentious, self-indulgent, craftless tat."

Duchamp's rejection of an effete artistic tradition was appropriate in 1917. It paralleled the radical political and social changes that were sweeping the world. A decade earlier Picasso was fully justified in creating *Les Demoiselles d'Avignon*. It was a reasoned progression by one of the finest draughtsmen of the twentieth-century. Mark Rothko took abstraction to its ultimate, incandescent conclusion. Lucien Freud, Anselm Kieffer, David Hockney and others have bravely taken an entrenched position by continuing to work with respect for traditional æsthetics. Other artists and craftsmen maintain the proven skills that gave art intrinsic value. They are however, like those medieval monks in the Dark Ages, working in obscurity, far from the madding crowd. The creation of art is not simply a vocation, still less a trade or profession, it is a genetic imperative.

Culturally at the start of the third millennium where the so-called fine arts are concerned, we have entered not so much a new dark age but a vacuum, where destruction is the only motive force.

Deconstructivism in art begins with the deconstruction of reason. In the visual arts this has been demonstrated by recent controversial shows at the Royal Academy and Tate Modern (where paradoxically, in the turbine hall of this temple of modern art, the architects have eschewed modernity

Gaynor Chapman,
'Upper Paleolithic Cave Ritual',
from 'The Dawn of Civilisation'
Thames and Hudson, 1961.
Reproduced with kind permission

8

Foreword

Since it began life almost eighty years ago as the listings magazine of the BBC, *Radio Times* has illustrated its brief announcements of programmes with illustrations commissioned from some of the best artists of the day. These little images will stir nostalgic memories in many people whose memories of public events and whose favourite entertainments have come though radio and television. They carry the history of Britain in the twentieth century in all its variety from the lighter sides of popular culture to the most serious consequences of international events. But they are also works of art of the finest quality. As Martin Baker has pointed out, the artists who worked for *Radio Times* were heir to a tradition which originated much earlier in the British illustrated publications of the nineteenth century. They also represent this tradition in one of its finest moments. It is, as he notes, a paradoxical history where artists of the highest calibre worked for an ephemeral publication against the most demanding of deadlines. Perhaps the success of the art of *Radio Times* is connected with the situation of many artists trained in the figurative tradition who found increasing difficulties in working against the grain of the fashion for non-figurative art. Possibly, as the spread of photography increasingly reduced the scope for magazine illustrators, *Radio Times* became the one of the few outlets for work by the cream of British illustrators. It may have been the result of enlightened patronage. Probably it was a mixture of all three. These questions are all raised by Martin Baker's lively text which will awake new interest in this exemplary publication. We are deeply grateful to him for his efforts in bringing all this material together from scattered sources and reminding us of the pleasure which many of us associate with the illustrations of the *"RT"*. The exhibition was researched, curated and assembled for us by him and it is to him that we are chiefly in debt. But he has been most generously seconded by the many artists and lenders who are warmly thanked for their support, Jacquie Kavanagh, Carole Burchett, and Neil Somerville at the BBC Written Archive have been particularly helpful as has Albert Cane's assistance in transporting works. On the Oxford side it has been handled with characteristic skill by Julie Summers and Jon Whiteley. But the entire enterprise would not have been possible without generous support from the Chris Beetles Gallery, London. We also warmly acknowledge the help of Darby's, Oxford's leading firm of solicitors, and of BBC Worldwide. We hope that they will take as much pleasure in this exhibition as it has given to its organisers.

Christopher Brown
Director

The exhibition is affectionately dedicated to

R O B I N J A C Q U E S

1920 - 1995

Contents

Foreword **7**

Art and Delusion | *Martin Baker* **9**

Artists of Radio Times **15**

A Student at the Central School of Art & Crafts 1936-40 | *Margaret Levetus Till* **65**

The Artists **69**

Notes **95**

Acknowledgements **96**

*Victor Reinganum,
'Muffin the Mule',
Radio Times,
21st December 1951*

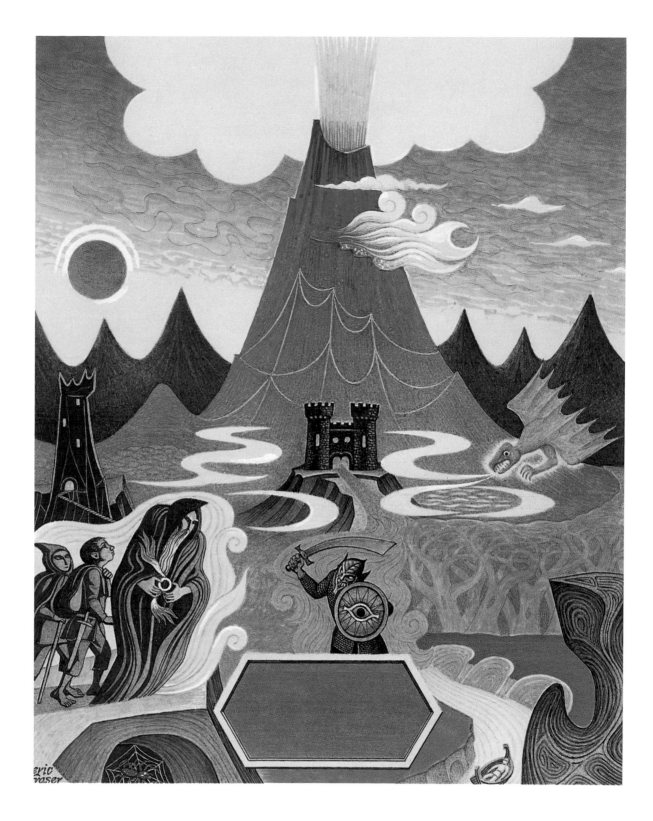

Eric Fraser,
'Lord of the Rings',
Radio Times, cover,
1981

Artists of Radio Times

A Golden Age of British Illustration

Martin Baker

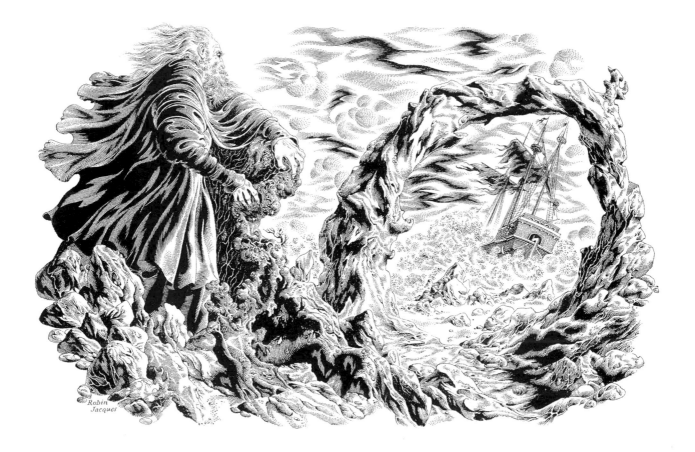

The Ashmolean

BEAUMONT STREET, OXFORD

Published to coincide with the exhibition curated by Martin Baker at the
Ashmolean Museum, Oxford 11 June - 7 August 2002.

Exhibition sponsored by BBC Worldwide, the Chris Beetles Gallery, London,
Darbys (Solicitors), Oxford and Critchleys, Chartered Accountants, Oxford.

Catalogue researched, written and designed by Martin Baker.
Publishing Consultant - Ian Charlton

The publishers gratefully acknowledge the resource of David Driver's, *The Art of Radio
Times* (European Illustrations/BBC Publications, 1981), for primary research,
specifically in connection with the compilation of the biographical notes on the artists,
which appear between pages 70 and 94 of this book.

ISBN 1 85444 182 5

British Library Cataloguing in Publications Data
A catalogue record for this book is available from the British Library

Cover illustration: Peter Brookes, *The Proms,*
Radio Times, 15th August 1978.
Back cover illustration: Eric Fraser, *Autumn News Number,*
Radio Times, 7th October 1938.
Title page illustration: Robin Jacques, *The Tempest,*
Radio Times, 22nd February 1952.

Set in 10 on 14 point Garamond and Franklin Gothic.
Printed and bound in England by Cambridge University Press 2002.

Published jointly by the Ashmolean Museum, Oxford and
Chris Beetles Limited, London.

CHRIS BEETLES LIMITED darbys Critchleys
CHARTERED ACCOUNTANTS

Artists of Radio Times
A Golden Age of British Illustration

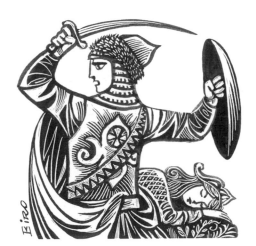

Val Biro,
'Ruslan and Lyudmilla',
Radio Times, c.1965